The Campus History Series

UNIVERSITY OF
ARKANSAS

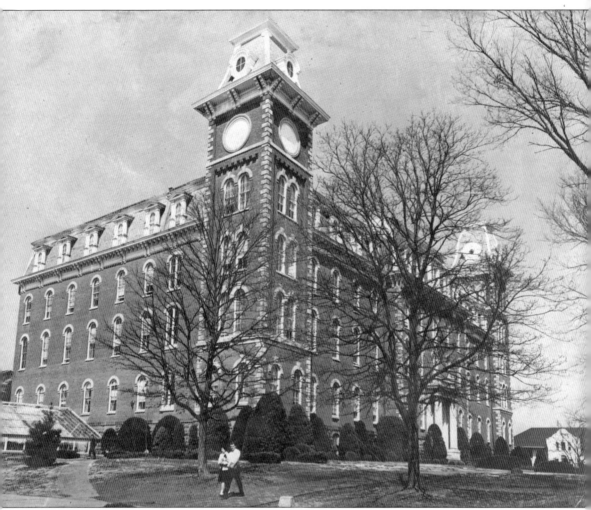

Old Main, the first permanent building on campus, was completed in 1875 at a final cost of $135,246.88. Most of the building materials were local and transported to campus by ox cart, including the 2.6 million bricks needed for the project. The university did not have the funds to finish the whole building, and the third and fourth floors, along with the basement, were finished around 1883. (Picture Collection OV5-16.)

On the Cover: Walter J. Lemke teaches a photography class in front of Old Main sometime between 1943 and 1946. Lemke was a professor in the journalism department from 1928 to 1959 and took many of the photographs that appear in this book. (MS L541, Image 79.)

The Campus History Series

UNIVERSITY OF ARKANSAS

AMY LEIGH ALLEN AND TIMOTHY G.NUTT

ARCADIA
PUBLISHING

Copyright © 2015 by Amy Leigh Allen and Timothy G. Nutt
ISBN 978-1-4671-1453-0

Published by Arcadia Publishing
Charleston, South Carolina

Printed in the United States of America

Library of Congress Control Number: 2015935029

For all general information, please contact Arcadia Publishing:
Telephone 843-853-2070
Fax 843-853-0044
E-mail sales@arcadiapublishing.com
For customer service and orders:
Toll-Free 1-888-313-2665

Visit us on the Internet at www.arcadiapublishing.com

CONTENTS

ACKNOWLEDGMENTS

Special Collections, a division of the University Libraries, was established in 1967 with a mission to collect and preserve Arkansas and regional history, as well as to document the state's role in the international community. The holdings reflect the diverse history of the state and its citizens and include materials documenting each corner of the state: from a housewife's diary in Chicot County to the political papers of Sen. J. William Fulbright and other politicians. Because of Senator Fulbright's history with the university and his commitment to cultural understanding, the holdings of Special Collections are particularly strong in international education; those documenting the Civil War, women's history, and state and national politics are also heavily represented. Special Collections is the largest academic archives in the state, and researchers from across the country and the world come to Fayetteville to utilize the world-class collections. We would like to extend a special acknowledgment to former employees Ellen Compton, Andrea Cantrell, Tony Wappel, and Ethel Simpson for their success in documenting the history of the University of Arkansas. Their previous work made our research easier.

The authors would like to especially thank Heath Robinson for scanning the selected images. Without his invaluable assistance, this project would not have been possible.

All of the images used in this book are held by the Special Collections at the University of Arkansas Libraries.

INTRODUCTION

Almost a decade after the passage of the Morrill Act of 1862, the Arkansas Industrial University was created by the Arkansas Legislature. The Morrill Act provided means for the states to establish universities for the purpose of teaching agricultural and mechanical arts. The Civil War and Reconstruction delayed Arkansas's actions in response to the act until 1868, when the university was established. It was another three years, on March 27, 1871, that the board of trustees were charged with selecting a location for the institution.

Officials from around the state expressed their interest in locating the school in their respective towns and held bond elections in efforts to bolster their chances. Washington County approved $100,000 in 30-year bonds. Fayetteville supplemented the bid with an offer of $30,000 as startup funds. This was more money than offered by Prairie Grove, which also vied for the university. Fayetteville stalwart Lafayette Gregg served on the board of trustees, and his stature and influence no doubt was one of the reasons for the city being selected in October 1871. The northwest Arkansas city, though, had been home to several educational institutions prior to the Civil War, including the Fayetteville Female Seminary and Arkansas College, and this might have been a factor as well.

The deadline to comply with the Morrill Act necessitated quick action by Fayetteville officials since the school had to open by February 1872. The board purchased 160 acres from the McIlroy family in November 1871, and a farmhouse located on the land was refitted into classrooms. Arkansas Industrial University opened on January 22, 1872, with eight students, including one female. Noah Gates served as the university's first president. The name of the university was changed to the University of Arkansas in 1899.

Since its founding, the U of A has been the state's university—not only in the sense of the flagship institution, but also as the school that represents all of Arkansas and her citizens. Students from around Arkansas dream of attending the U of A, an institution intertwined in the culture and history of the state. The people, buildings, and traditions have become integrated into our lexicon, thoughts, and collective history.

University Hall, the oldest building on campus, known today as Old Main, opened in 1875 and was used for classrooms and administrative offices. It was built using local materials, and the aforementioned Lafayette Gregg oversaw the construction of the building to ensure it was built to specifications. Though there was a push to demolish the building in the 1980s after it had fallen into disrepair, preservationists, alumni, and others rallied for its restoration. Today, it continues to stand beacon over northern Arkansas and remains one the most iconic buildings in the state.

Campus traditions abound at the university. A particularly treasured one is the Senior Walk. Inscribed in miles of cement sidewalks around campus are the names of the institution's alumni. A number of distinguished alumni appear on Senior Walk, including former university president and US senator J. William Fulbright, internationally recognized architect Fay Jones, and Miss America 1964 Donna Axum. Another tradition is the calling of the hogs. Whether an alumnus or not, it is hard not to feel pride for the Razorbacks—and the state—when one hears the familiar "woo pig sooie" call in Razorback Stadium, Walton Arena, Barnhill Arena, or wherever a group of fans are gathered.

Athletics has always been inextricably linked to the U of A. Before the razorback became its mascot, the less-fierce cardinal held the honor. Hugo Bezdek, the head football coach from 1908 to 1912, is credited with comparing the football team, which had just routed Louisiana State, to a "wild band of razorback hogs." The name was an instant hit with the students, and the mascot was officially changed from the Cardinals to the Razorbacks. The name is unique to Arkansas, as no other college or professional team has a razorback mascot. Once part of the Southwest Athletic Conference, the Razorbacks now regularly dominate the Southeastern Conference in multiple sports. In 1964, the Razorbacks played for the national football championship, and the basketball hogs were the 1994 NCAA champions after defeating the Duke Blue Devils. Other teams (both men's and women's), such as track-and-field and gymnastics, have found success and earned international reputations. Over the years, a number of coaches and players have made their mark on Arkansas athletics, including Jerry Jones (football), Corliss Williamson (basketball), Lou Holtz (head football coach), Nolan Richardson (head basketball coach), and Bev Lewis (women's basketball coach).

The University is also proud of its history of diversity and inclusion. There is evidence that James McGahee, an African American student, studied at the university when it opened in 1872. Although he was most likely privately tutored by the university's first president, this type of inclusion was rare at the time, especially at Southern institutions. Silas Hunt became the first African American to be admitted to a major public Southern university without court order when he was admitted to the law school in 1948. He died a year later without obtaining a degree, but his actions paved the way for other black students at the U of A. The university has continued the tradition of inclusiveness to this day, including a diverse community of international students.

Academics remain at the center of the university's mission. There were no designated colleges or schools at the university until well into the 20th century. Academic departments were fluid and changed names through the years. Some professors taught in multiple departments, according to their backgrounds and strengths. The first college created was in agriculture. Since the beginnings of the university, agriculture has played an important role in its mission and curriculum, fulfilling the intent of the Morrill Act. Today, there are seven colleges and schools administering to the educational needs of the students. Enrollment has increased exponentially since the first class of eight in 1872, and the infrastructure has changed dramatically to keep up with the number of students and programs. However, the core of the university—a dedication to education—remains the same.

This book is not a comprehensive history of the University of Arkansas. Instead, the authors focused on the first 125 years of the institution's history and selected images that represented the diverse aspects of the colleges, students, athletics, and infrastructure. When feasible, an image from each decade from 1871 to 1996 was chosen. All of the images are from the holdings of Special Collections, a division of the University Libraries, which has diverse collections documenting not only the rich history of the university, but also all of Arkansas. It is the authors' hope that this book will evoke memories of your time on "the Hill."

One

BUILDINGS AND SPACES

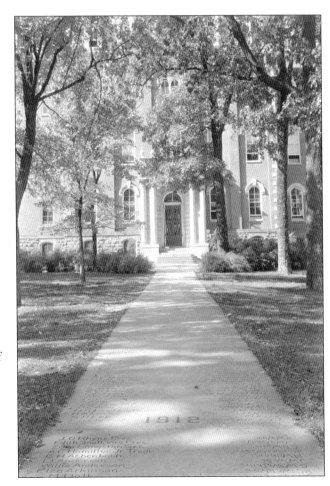

The buildings and spaces on campus serve as the backdrop for learning, entertainment, and lots of memories. The U of A hosts an eclectic mix of styles, from the ancient style of the Greek theater to collegiate Gothic, such as Memorial Hall, to mid-century modern with the fine-arts center. Two of the most iconic places are pictured here: Old Main and Senior Walk. (Picture Collection 1299n.)

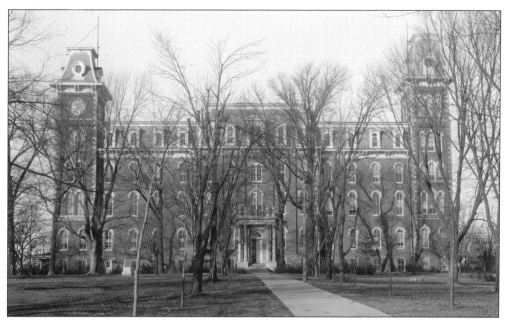

Old Main, first known as University Hall, was the first permanent building on campus and the only campus building from the 19th century that is still standing. The building contract was awarded to Mayes and Oliver of Fayetteville, and construction began in 1873. Despite setbacks, the first phase of the building was completed in 1875, several months ahead of schedule. (Picture Collection 1481a.)

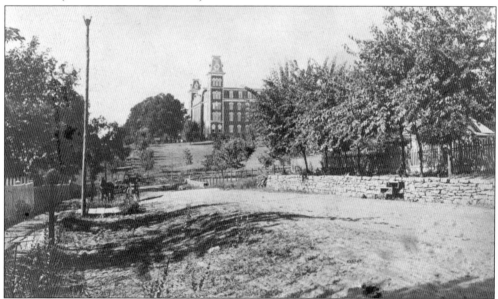

Old Main is seen from the vantage point of Leverett Street. In the beginning, Old Main was used for everything, including the library, chapel, museum, gymnasium, machine shop, classrooms, laboratories, and offices. Extra rooms were even rented for faculty members or students to live in. Old Main fell into disrepair and was closed in the 1980s due to safety concerns. Funds were raised to restore the building, and Old Main was rededicated in 1991. (Picture Collection 3608.)

The university started modestly in two wood-frame buildings in 1872. They were two stories tall and connected by an enclosed hallway. All classes and the meager library, which consisted of approximately 137 books, were housed in these buildings until Old Main was completed in 1875. (Picture Collection 1118.)

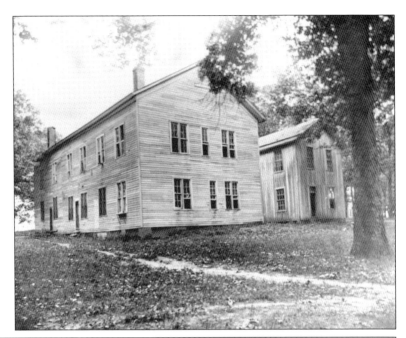

This photograph shows the first Agriculture Experiment Station, which was located on Maple Street behind the current home economics building. It was completed in 1888 under the Hatch Act for a cost of $4,000 and then furnished with another $4,000 worth of equipment. By the 1930s, the building was being used for music students and then later for editorial services before being torn down around 1970. (Picture Collection 2737.)

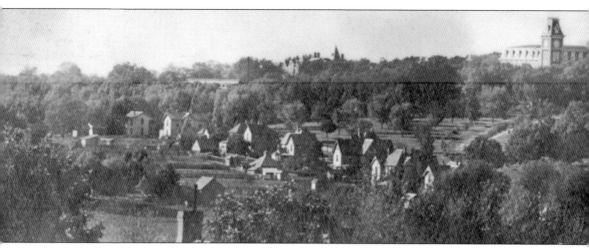

Old Main has dominated the skyline of Fayetteville and surrounding areas ever since its construction in 1875. Situated on one of the many hills in Fayetteville, the building has remained an iconic symbol of not only the flagship campus of the University of Arkansas system but also higher education throughout the state. Materials to construct the building were supplied through local sources. Bricks were made from clay deposits near Fayetteville, and

the bricks were fired in a local brickyard. Stone for the building was quarried in Washington and Madison Counties. Lafayette Gregg served on the building committee and personally oversaw the construction of Old Main. Previously, Gregg had been instrumental in securing the funding so the university would be located in Fayetteville. He also served on the board of trustees. (Picture Collection 3457.)

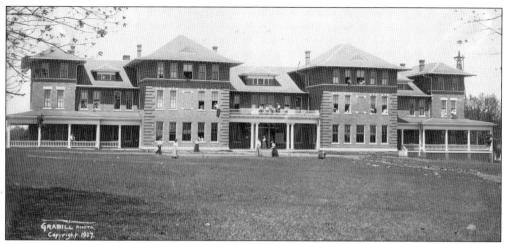

Ella Carnall Hall, the first women's dormitory on campus, opened in 1906. It contained a dining room, kitchen, parlor, library, and piano practice rooms. Beginning in 1967, the building was used as a fraternity house and then for the anthropology, geography, and sociology departments. After major renovation, the building reopened in 2003 as the Inn at Carnall Hall and Ella's Restaurant. (MC 1157, Image 2.)

The facilities building, shown here about 1910, housed the machine and wood shops, a foundry, and the boiler room. According to the 1910 catalog, the shops offered opportunities for students to understand how the machines operated to have a deeper understanding of the work. (MC 1157, Image 10.)

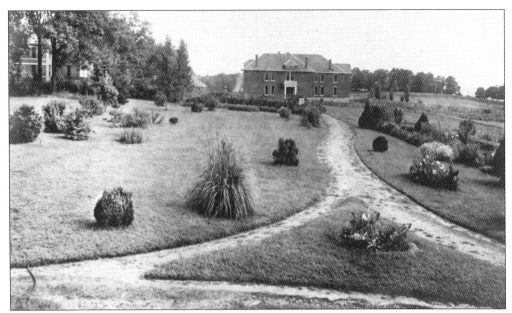

This c. 1910 photograph shows a rare glimpse of early landscaping and winding paths toward Hill Hall and Gray Hall, two of the early men's dormitories, completed in 1901 and 1905, respectively. Both of these buildings and this garden, located on what is currently the center of campus, have long been replaced by other buildings. (Picture Collection 3691.)

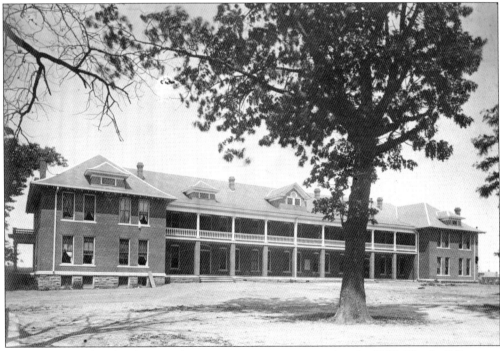

Gray Hall was the third men's dormitory on campus, opening in 1905. The building was patterned after US Army barracks. It contained 34 bedrooms on each of its two floors. Starting in the 1920s, it was used for the College of Agriculture until it was torn down in 1966. (MC 1157, Image 1.)

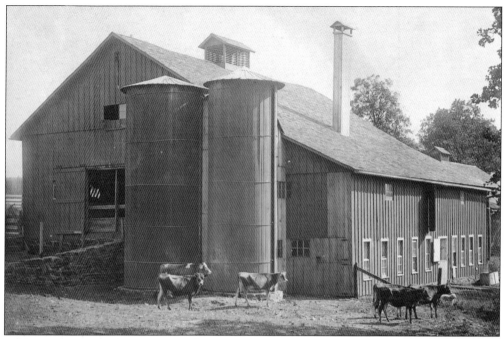

In the early 1900s, the university farm was located near the center of campus. The barn pictured here about 1910 has long since disappeared, although the university still runs an active farm. Even after 100-plus years, agriculture remains a core mission of the university. In 1995, the College of Agriculture was named for former Arkansas governor and US senator Dale Bumpers for his efforts to improve Arkansas agriculture. (MC 1157, Image 11.)

No, these are not captured razorbacks, but hogs raised on the campus farm. All types of livestock were kept so that agricultural students could study new methods and practices to improve farming techniques. Today, the university still operates a swine farm just north of campus. This photograph dates from about 1910. (MC 1157, Image 14.)

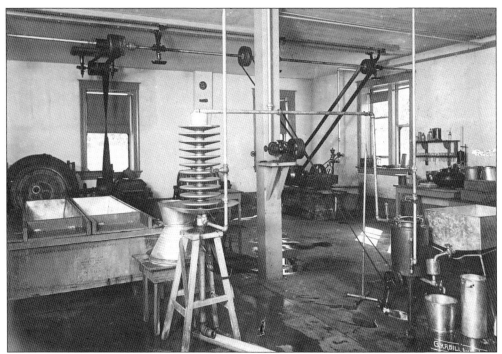

This 1908 photograph shows the interior of the creamery room, which was operated by the Departments of Animal Husbandry and Dairying. Here, the students had access to different types of pasteurizers, ripeners, and churns. The building that housed this creamery also contained a cheese-making room where students could manufacture cheddar cheese. (MC 1157, Image 23.)

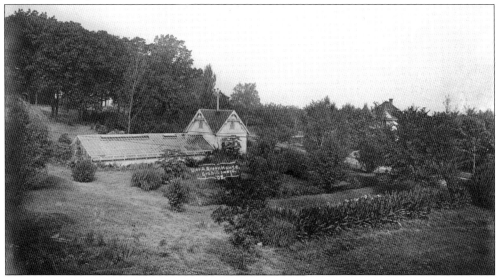

The greenhouse shown here in 1907 contained an inventory of ornamental plants used for indoor decoration and horticultural experiments. The horticulture department was recognized in 1897. In addition to greenhouses, the department offered instruction in soil preparation, plant management, obtaining new varieties, gardening, nurseries, and orchards. (Photograph by the Grabill photography studio, MC 1157, Image 4.)

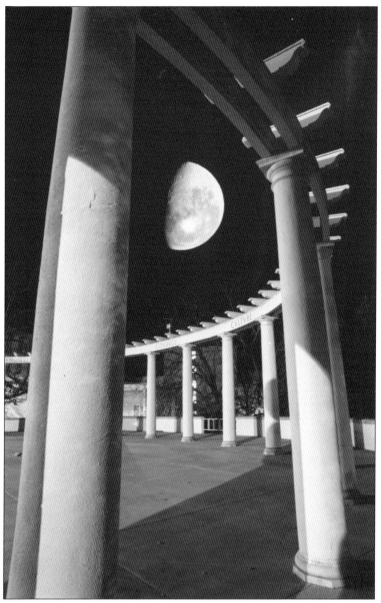

The Chi Omega Greek Theater is pictured here in the moonlight in 1988. The theater has been a fixture of the U of A campus since 1930. It was a gift from the Chi Omega women's fraternity and was the first gift of its kind from a Greek organization to a university. Chi Omega was founded on the U of A campus on April 5, 1895. The founders were Ina Mae Boles, Jobelle Holcombe, Alice Carey Simmonds, and Jeanne Marie Vincenheller, with the aid of Dr. Charles Richardson, who was a member of Kappa Sigma. Richardson became the sole honorary member of Chi Omega. Chi Omega is now the largest women's fraternal organization in the world, with over 300,000 initiates. The theater was modeled after the Theater of Dionysus in Athens, Greece. Since its dedication in June 1930, the theater has been used for concerts, plays, commencements, and pep rallies. It is also a popular place for studying, relaxing, and meeting friends. The theater was added to the National Register of Historic Places in 1992. (MC 1302, 1988-957.)

Vol Walker Hall opened in 1935 as J. Vol Walker Memorial Library, the main library for campus. The building was funded as a Public Works Administration project and named for James Volney Walker, a prominent Arkansas lawyer and a U of A alumnus from 1877. When a new library was constructed in 1968, the building became home to the School of Architecture. (Picture Collection 1372.)

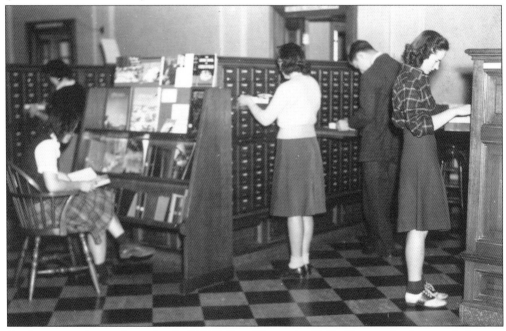

Students use the card catalog in Vol Walker Library in 1942. Those who have only known online catalogs will be unfamiliar with this manual way of thumbing through drawers of cards, sorting books by title, author, and subject. This photograph is part of a series by Walter Lemke for a study his journalism class conducted on the library. (Picture Collection 1405.)

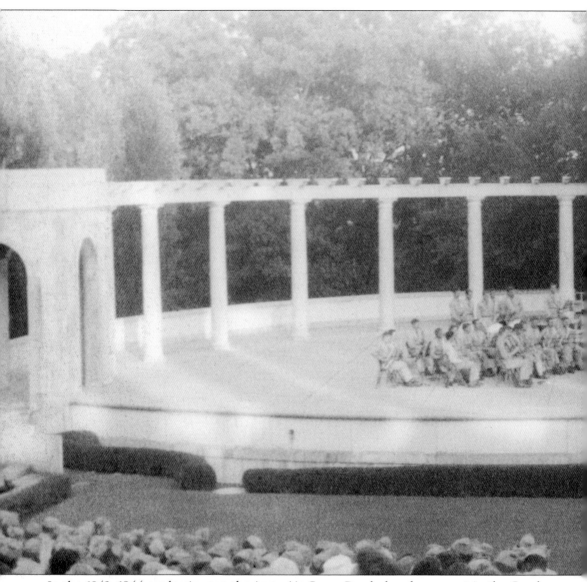

In the 1943–1944 academic year, the Army Air Corps Band played a concert in the Greek theater to a crowd of about 6,000. During World War II, the campus hosted Army Air Corps training, and soldiers with musical talent joined the ROTC band to perform concerts and, in 1943, to march together in Razorback Stadium. Up to this point, bands on campus originated from the military department. By the early 19th century, the band was playing during some

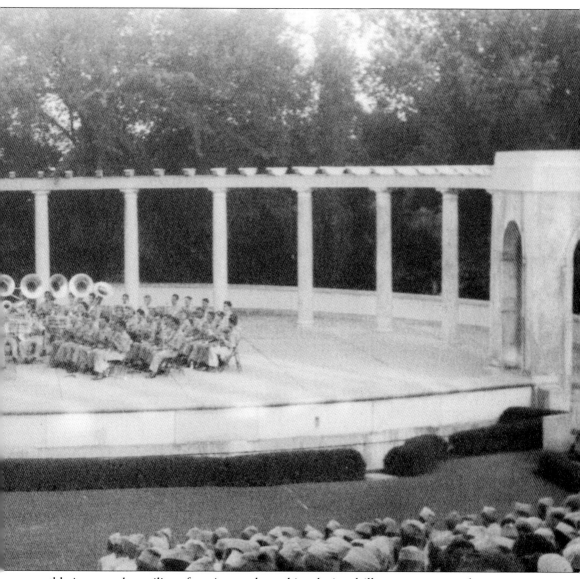

athletic events, but military functions and marching during drill maneuvers were their primary function. By 1935, some of the members of the ROTC band were chosen for a separate athletic pep band. Concerts started around 1926 to allow the band to be the main attraction rather than just part of a military function or athletic event. (MS L541, Image 1029.)

The track and football field surround Schmidt's Barn. Named after Francis A. Schmidt, head coach of the football, basketball, baseball, and track programs during most of the 1920s, the "barn" was actually a wooden garage that had been moved to campus around 1923 to serve as a basketball gym and dressing rooms. The building was located near where the fine-arts building now stands. (Picture Collection 1289.)

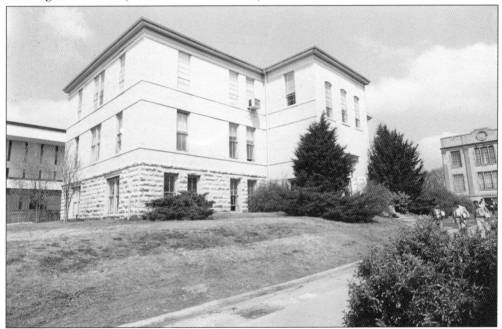

Students walk past Hill Hall in 1980. It was the second men's dormitory on campus, completed in 1901. In 1949, it was turned into a print shop, journalism classrooms, and offices. In 1969, a fire destroyed part of the building, but it was reconstructed the next year. The building was torn down in 1997 during an expansion of Mullins Library, but a cornerstone from Hill was incorporated into the addition. (MC 1302, 1980-63.)

The Spoofer's Stone has become a fixture of the U of A campus. The Spoofer's Stone was a piece of limestone meant for the construction of Old Main. This particular stone fell off the ox cart it was being transported on and broke. Unsuitable for construction, the stone was left on the Old Main lawn after construction finished. In the early days of campus, when men and women were kept separate, the cracks of the Spoofer's Stone were used to discretely pass love notes. Later, it was a popular place for marriage proposals. The women of the class of 1933 became distraught by the stone's crumbling state and raised money to have a concrete base and commemorative plaque made for the stone so that it would remain intact for generations to come. (Picture Collection 2400.)

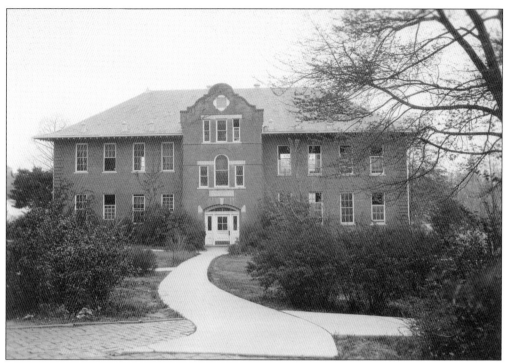

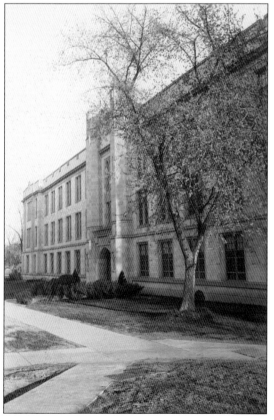

This is the original chemistry building, constructed in 1905. When the new one was constructed in 1935, this building became the law school. Students moved the law library from Old Main in wheelbarrows, and the building was painted white. After the new law building was finished, this was used for psychology, geography, and social work. (Picture Collection 1023.)

A new chemistry building was completed in 1935. The additional space allowed the department to expand both in students and classes offered. The following year, the department saw a 28.5 percent increase in students, bringing the department to about 600 students. The department was also able to add back classes, which had not been available previously due to a lack of laboratory space. (Picture Collection 1035.)

Waterman Hall was the first building constructed specifically for the law school. It was dedicated in 1953 and named after Julian Waterman, who established the law school at the U of A in 1924 and then served as the school's first dean. Waterman Hall was expanded in 1975. (Picture Collection 2731.)

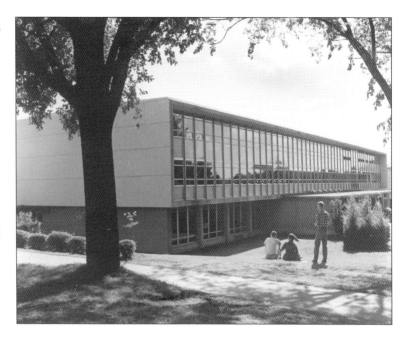

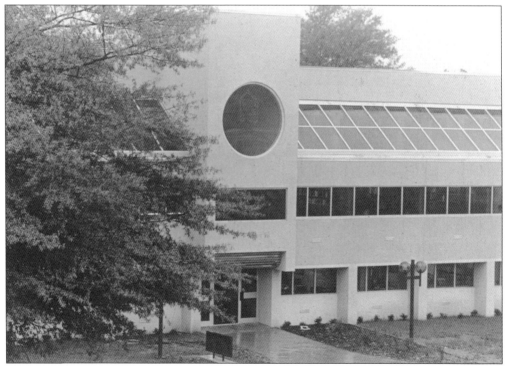

In 1986, Waterman Hall was expanded into the Leflar Law Center. The law center was expanded again in 2007. It was named for Robert A. Leflar, who graduated from the U of A, served as a law instructor, and was the second dean of the law school. (Picture Collection 4718.)

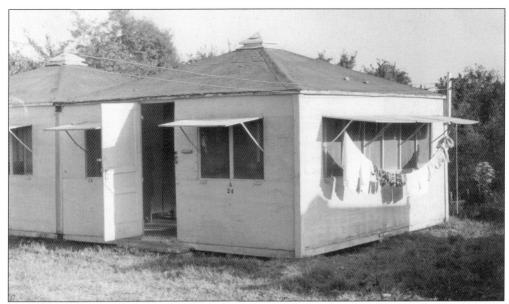

Camp Leroy Pond provided student housing for 1,200 World War II veterans and included 300 wooden huts, dining facilities, and other buildings. The camp was established in 1946 near Razorback Stadium and named in honor of graduate Leroy Pond, known as "Fireball" for his reddish-blond hair and fearless attitude. Pond died in 1945 from battle injuries. Camp Leroy Pond was demolished in the late 1950s to make room for married student housing. A street bearing Pond's name remains on the U of A campus. (MC 1860.)

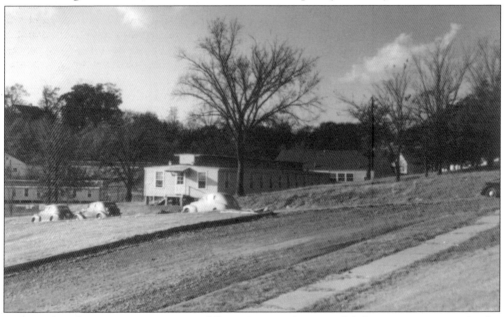

Six wooden dormitories were moved from Bauxite in central Arkansas to campus in the late 1940s to meet temporary housing demands for returning World War II servicemen. The buildings—known as Lloyd Halls—were named after Congressional Award recipient Edgar "Buck" Lloyd (BSA, 1943), who had been killed by enemy sniper fire in France in 1944. The Lloyd Halls served as dormitories until 1955, when the buildings were demolished. (MC 1860.)

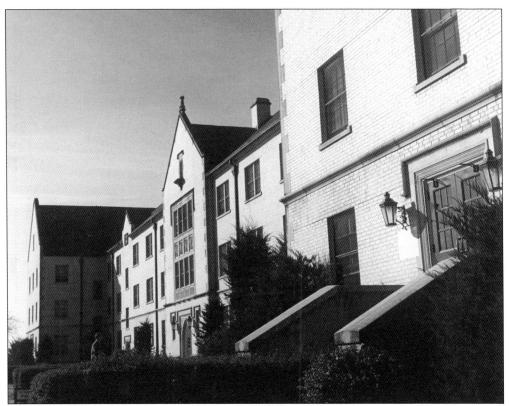

Gregson Hall opened as a residence hall in 1948 in the post–World War II boom and was named for William S. "Pop" Gregson. When it opened, the house was able to accommodate 208 male students plus two counselors. The building featured more than just dorm rooms, including a cafeteria, snack bar, laundry room, mail room, telephone switchboard, barber shop, and reading room. (Picture Collection 1622.)

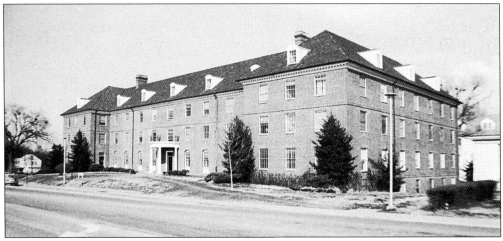

Holcombe Hall opened in 1948, although the girls had to spend the first few days living in Lloyd Halls. Workmen continued to finish the building for the first few months of the semester. Holcombe Hall was named for Jobelle Holcombe. It is pictured here in 1982 and continues to be used as a dormitory into the 21st century. (MC 1302, 1982-39.)

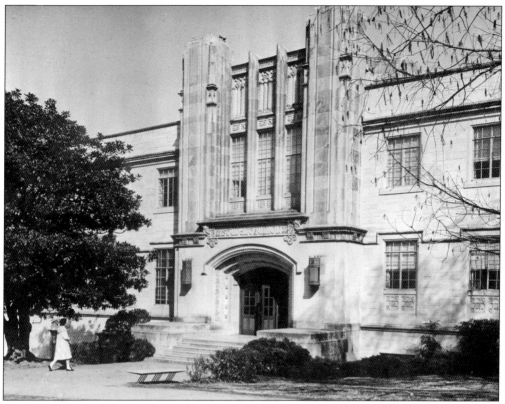

Memorial Hall was the first student union on campus. It was officially named Futrall Memorial Hall after alumnus and U of A president John C. Futrall, who was killed in a car accident in 1939 during the construction of the building. After the new student union was constructed in the 1970s, the building has been used for the psychology department and Air Force ROTC. (Picture Collection 1324.)

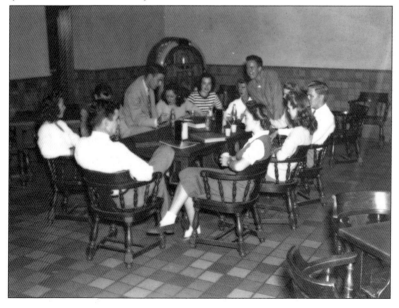

Students are seen relaxing at a table in the original student union, Memorial Hall. A jukebox resides in the corner. The student union also housed the campus bookstore, a lunch room, soda fountain, barber shop, billiard room, lounge, ballroom, and offices. (Picture Collection 1341.)

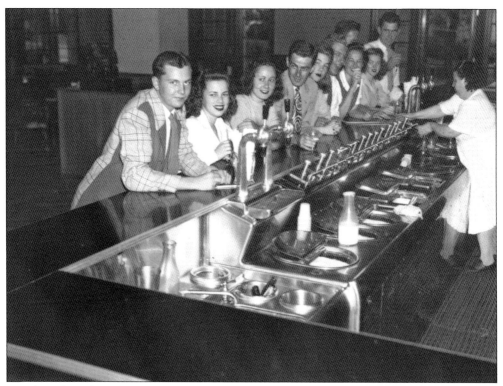

Jovial students line the soda fountain counter in Memorial Hall. The fountain room in the student union was a central gathering place—the place to go to see and be seen. Students could grab a bite to eat, get a coffee or a soda, play games, or just sit and talk. (Picture Collection 1333.)

Many may think coffee shops on campus are a new idea. A student waits here in the coffee line in Memorial Hall in the 1950s. While students have been able to get a cup of coffee for decades, the choices during the time of this photograph were probably limited to black coffee or coffee with cream and sugar. (Picture Collection OV5 118.)

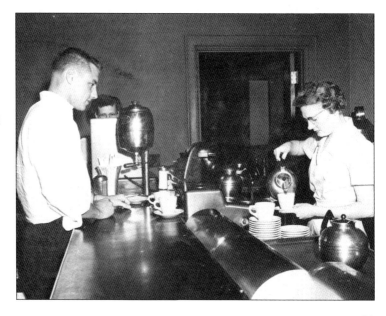

29

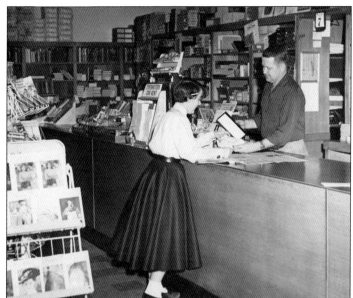

Carol Lynn Lackey makes a purchase at the bookstore on December 15, 1954. That year, the bookstore was housed in the student union, Memorial Hall. It sold textbooks, school supplies, and fiction books and bought used textbooks, just like today. The bookstore moved to the new student union when it was opened in the 1970s and then moved to the Garland Center in 2010. (Picture Collection 2424.)

The distinctive grill of Carlson Terrace is elegantly presented in this photograph of the married student housing facility. Designed by Arkansas native and internationally known architect Edward Durell Stone and built between 1958 and 1964, the International-style apartments served to address the housing needs of married students. The apartments were located south of Razorback Stadium and remained open until their demolition in 2007 due to deteriorating infrastructure issues. (Picture Collection 1579.)

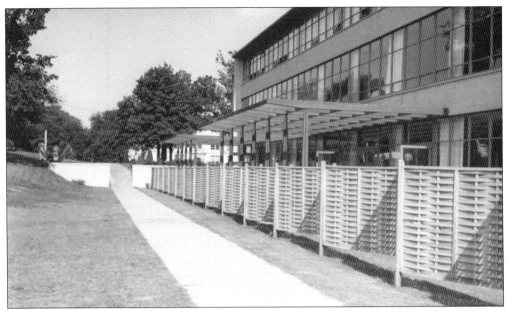

The fine-arts center was designed by architect Edward Durell Stone and dedicated in 1951. The center is actually three buildings connected by a gallery, drawing on the idea of having performing- and fine-arts programs combined under one roof. The music, drama, architecture, and speech departments now have their own teaching spaces, and the art department is now the building's primary tenant, although drama and music still utilize performance space. A branch of the university libraries is also located in the building. The International-style building is filled with windows to take advantage of the natural light and now-obscured views of the Ozark Mountains. The north facade, shown above, features a now-dismantled distinctive privacy fence, while the photograph below shows the outdoor amphitheater located on the west side of the building. (Above, Picture Collection 1110; below, Picture Collection 1598.)

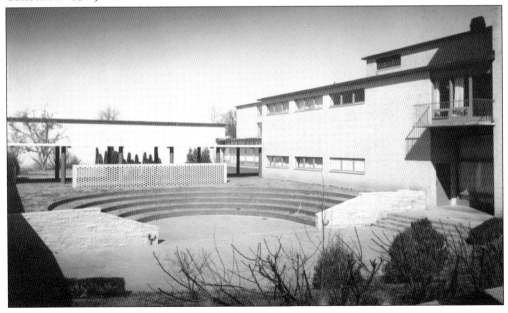

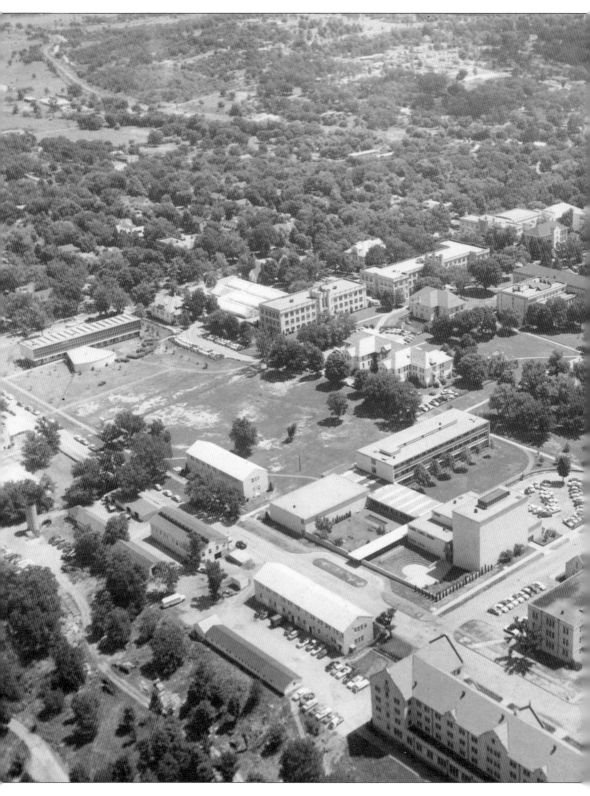

This aerial photograph from about 1958 shows the growth of the university. Old Main dominates the campus. The open area located in the center of campus would eventually be covered with concrete and surrounded by new buildings during the 1960s and 1970s, including a student union on the west. Gray Hall, the white building situated on the east side of the green space, was razed in 1966 to make room for a new library. The building on the north side of the green space is Waterman Hall, while the fine-arts building graces the south side. The areas to the northeast and west around campus were still rural at this time. (Picture Collection 941.)

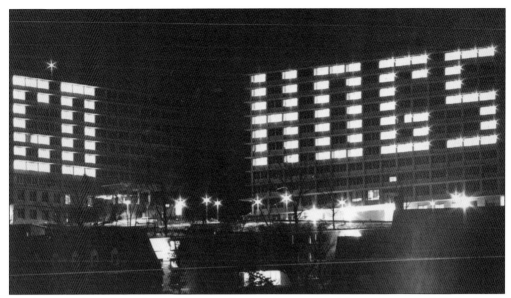

School spirit has always been an integral part of university life, and it is on full display in this 1960s photograph by John Woodruff. The dormitory residents have cleverly coordinated lights in their rooms to show their support of the Razorbacks. While the dormitories pictured are unidentified, there is indication that they are Yocum and Humphreys. (MC 2016.)

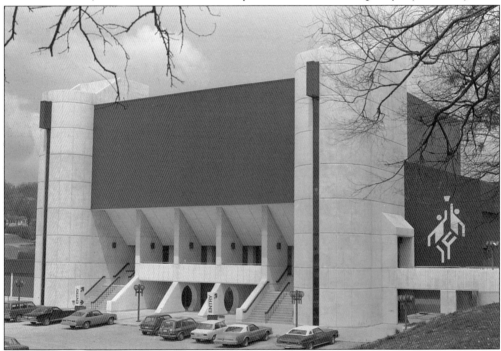

Barnhill Arena, seen here in the 1980s, opened in 1954 as the Arkansas Fieldhouse. Renamed in 1973 for former coach John Barnhill, it was considered by Razorback opponents to be a tough venue to play because of the intensity of Arkansas fans. After the men's basketball team moved to Bud Walton Arena in 1993, the facility was used for women's basketball and then later repurposed for gymnastics and volleyball. (MC 1302, 1980-61.)

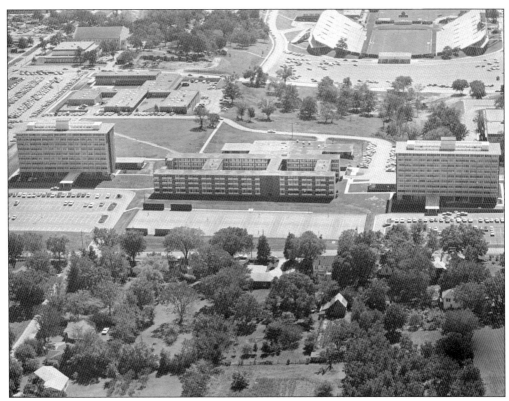

This aerial photograph from the 1980s features the north side of campus. In the foreground, are, from left to right, Hotz, Fulbright, and Reid dormitories. Directly behind Hotz is the animal-science center, and Razorback Stadium is in the upper right. Fulbright Residence Hall was built in 1961 and demolished in 2001 to make way for the new Maple Hill multi-use housing facility. (MC 589, Image 414.)

Fans file into Razorback Stadium to watch a football game during the 1960s. The stadium was constructed in 1938. The facility was known as Razorback Stadium from 1941 to 2001, at which time it was renamed Donald W. Reynolds Razorback Stadium. It has been expanded over the years, most recently in 2001, bringing the seating capacity close to 80,000. (Picture Collection 1352.)

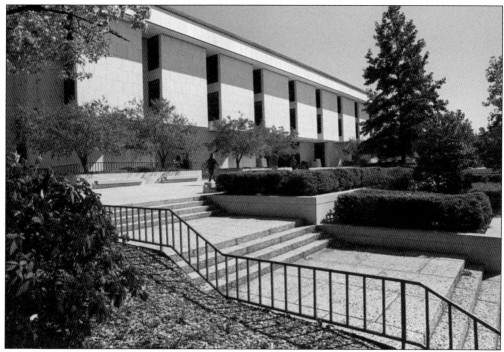

Pictured here in 1988, Mullins Library, the current library on campus, was built in 1968 right next to the previous library, Vol Walker, in the center of campus. In 1975, the library was named after U of A president David Mullins. (MC 1302 1988-909.)

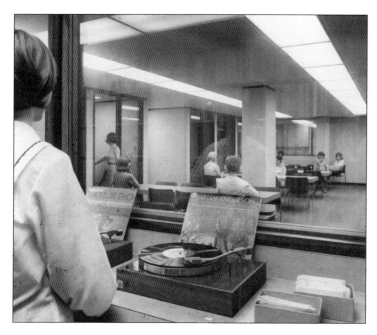

Mullins Library consists of more than just books. Pictured here is the audiovisual listening area just after the library opened in 1968. The library offered additional spaces for using audiovisual materials, microfilm, maps, and in much later years, computer labs. The new library was a place to use books and other materials, not just store them. (Picture Collection 4193.)

A new student union opened in the fall of 1973. Besides recreational spaces, the new union offered meeting, office, or working space for student groups upon request. The area in front of the union, the Union Mall, is rarely seen empty when classes are in session. The mall becomes a place for celebrations, fundraising for student groups, expressing ideas, playing Frisbee, or just watching the activities. When the union first opened in 1973, the university celebrated with Arkansas Union Week, filled with movies, lectures, art exhibits, and a game of pool in the new recreation room where U of A president David Mullins and Gov. Dale Bumpers played against Associate Student Government (ASG) president Rick Campbell and union president Henry Woods. Below is the main staircase of the union in 1978. (Above, MC 1302, 1980-63; below, MC 1302, 1978-25.)

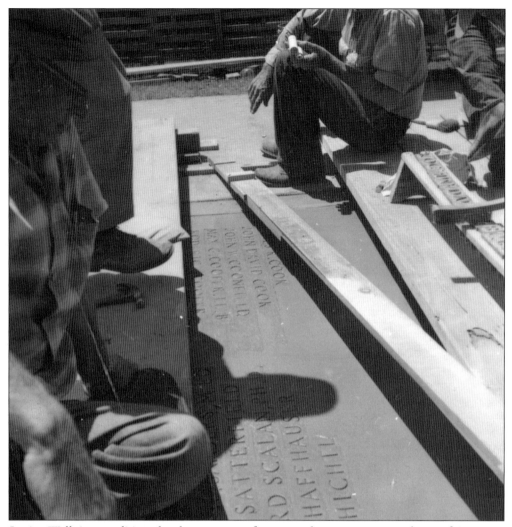

Senior Walk is a tradition that has gone on for more than a century at the U of A. It was started by the class of 1905 when the names of the graduating seniors were written in wet cement on the sidewalk just in front of Old Main's front door. Later slabs were added for all of the previous graduating classes, and students in every graduating class since have had their names permanently added in concrete. For decades, the names were hand-stamped in the wet cement by members of the physical plant, as seen here. As the graduating classes grew, this became a more time-consuming task. In 1986, employees of the physical plant invented the "Sand Hog," a machine specifically invented for this purpose. Senior Walk stretches for more than five miles, winding its way through campus, listing over 180,000 names. (Picture Collection 2743.)

The two towers of Old Main are visible for miles. The south tower was built for a clock; however, a timepiece was not installed until 2005. The north tower was built for a bell, and the first one was purchased around 1879. On May 1, 1949, a set of carillon bells in Old Main was dedicated to the 210 students who lost their lives in the two world wars. The money for the bells was originally meant for a memorial chapel, but it was repurposed. Below, Joe Talley, facility's manager, is photographed with the old bell, which was rung on July 4, 1976. This was only the second time this bell had been rung since the carillon bells were installed. (At right, Picture Collection 1482; below, MC 1302, 1976-104.)

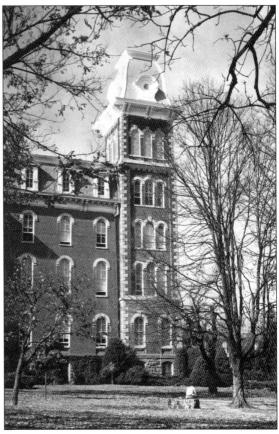

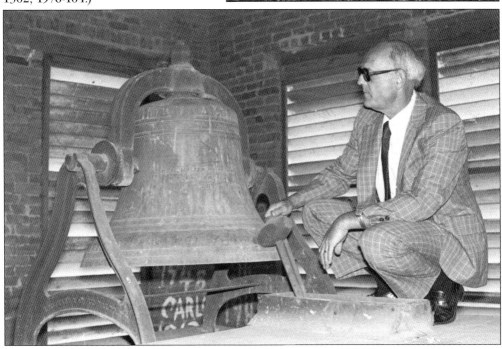

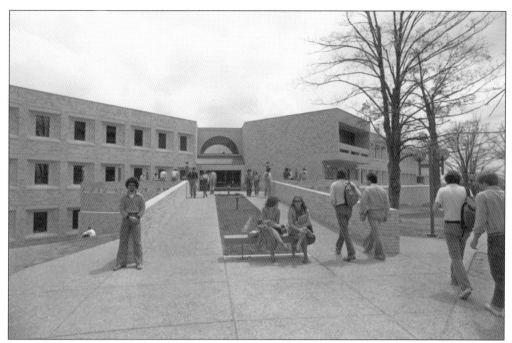

In the spring of 1978, the College of Business moved into the new business administration building. The College of Business made headlines in 1998 when it received a donation of $50 million from the Walton Family Charitable Support Foundation. It was the largest single gift given to an American business school. Shortly after, the college was renamed the Sam M. Walton College of Business Administration. (MC 1302, 1980-60.)

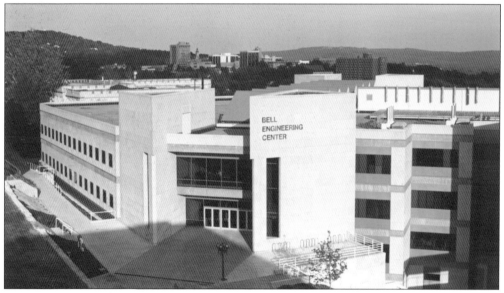

The Bell Engineering Center opened in January 1987. In addition to classrooms and laboratories, the building housed the chemical engineering, civil engineering, electrical engineering, and industrial engineering departments. The building was constructed along Campus Drive, which used to be a main entrance to campus. It features a ramp that runs the length of the building and follows the old Campus Drive. (MC 1302, 1988-408.)

Two

PEOPLE

It takes administrators, faculty, staff, and students to keep a university running. Some of the well-known people who have played a part in the campus include Sen. J. William Fulbright, Bill and Hillary Clinton, architects Fay Jones and Edward Durell Stone, and entertainers Lum and Abner. John C. Futrall is shown here in his school uniform around 1892. Later, Futrall served as a professor, the first football coach, and U of A president. (Picture Collection 2494.)

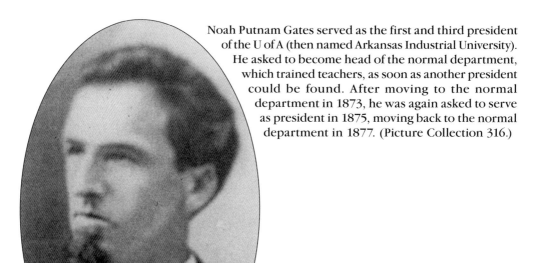

Noah Putnam Gates served as the first and third president of the U of A (then named Arkansas Industrial University). He asked to become head of the normal department, which trained teachers, as soon as another president could be found. After moving to the normal department in 1873, he was again asked to serve as president in 1875, moving back to the normal department in 1877. (Picture Collection 316.)

John C. Futrall was a professor of Latin and Greek from 1894 to 1913. In addition to teaching, he served as the first football coach until a professional coach was hired in 1901. In 1913, he became U of A president and served until he was killed in a car accident in 1939. The student union then under construction was named Futrall Memorial Hall in his memory. (Picture Collection 311.)

Ella Howison Carnall graduated in 1881 from the U of A (then called Arkansas Industrial University) and immediately began teaching in the preparatory department, a position she retained until 1884. She earned an advanced degree at the University of Michigan before returning to the U of A, where she was an associate professor of English and modern languages from 1891 to 1894. (Picture Collection 2676.)

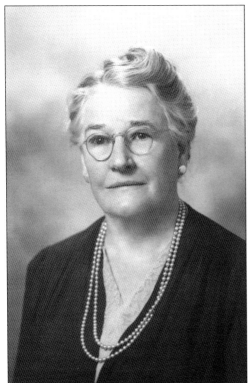

Jobelle Holcombe was a founder of Chi Omega in 1895 and graduated from the U of A in 1898. She taught in the preparatory department from 1902 to 1903 and in 1906. In 1907, she became an English instructor and served as dean of women for four years. She continued to teach until 1942. In 1947, she was the first woman at the U of A to receive an honorary doctor of laws degree. (Picture Collection 404a.)

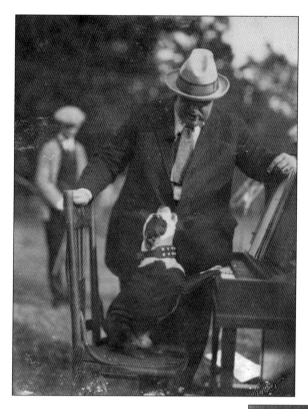

Music professor Henry Tovey listens to a musical performance by his dog around 1930. Tovey was a gifted pianist and served as head of the Department of Fine Arts for 25 years, beginning in 1908. Tovey wrote the music for the university's alma mater. The words were written in 1909 by Brodie Payne. Tovey died in 1933 but left a lasting legacy through his music. (MC 779, Image 888.)

Hugo Bezdek is credited with christening the football team the Razorbacks after the players ended the 1909 season undefeated. The new name stuck, and the mascot was officially changed from the Cardinals to the Razorbacks. Bezdek arrived at Arkansas in 1908, and the 24-year-old head coach led the team to a string of winning seasons. He left the university in 1912. (MS R33, Image 72.)

Edward Durell Stone was born in Fayetteville, Arkansas, and studied at the U of A, the Boston Architectural Club, Harvard Architectural School, and the Massachusetts Institute of Technology, though he never finished a degree program. Stone designed buildings all over the world, including the Museum of Modern Art in New York City (in association with Phillip Goodwin) and the John F. Kennedy Center for the Performing Arts in Washington, DC. He designed buildings in India, Panama, Belgium, Pakistan, and Puerto Rico. Above, Stone sits with his Sigma Nu pledges about 1920. From left to right are Stone, Lewis Davis, Fletcher Minnis, and John Bagby. At right, Stone is pictured receiving a Distinguished Alumnus Citation in 1965. (Above, MC 1427; at right, Picture Collection 822.)

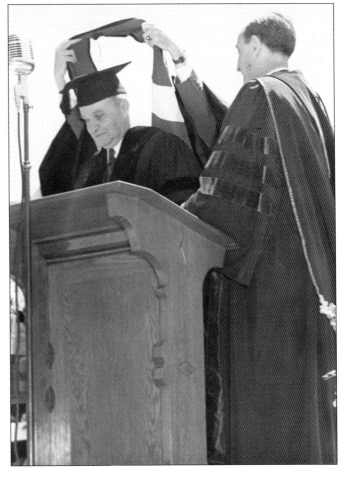

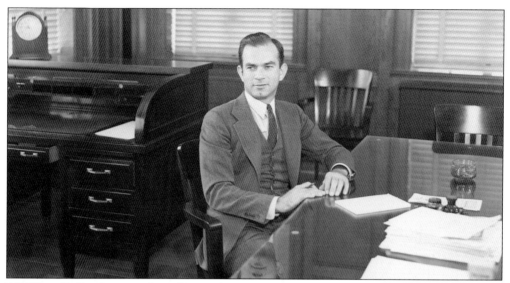

J. William Fulbright sits in his office at the University of Arkansas while serving as president of the institution about 1939. Fulbright earned a degree in political science from the U of A in 1925 and later was appointed president of the school in 1939. At the time, he was the youngest university president in the country. He served in that capacity until he was ousted in 1941 in a bitter political battle with Gov. Homer Adkins. Later, in 1944, Fulbright was elected to the US Senate, soundly defeating Adkins. While his accomplishments in the Senate are legendary, including the creation of the international exchange program that bears his name, Fulbright is also remembered as a capable and effective university president. The College of Arts and Sciences at the U of A was named in his honor in 1981. (MS L541, Image 530.)

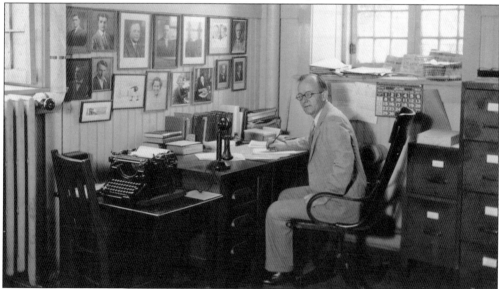

Walter J. Lemke is pictured here in his office in June 1931. Lemke established the journalism department in 1928 and served as head until 1959. In addition to teaching, he did public relations for the U of A and supervised campus publications. He was active on campus and in the community. He kept up with many of his former students and produced a regular newsletter for former students during World War II. (MS L541, Image 2.)

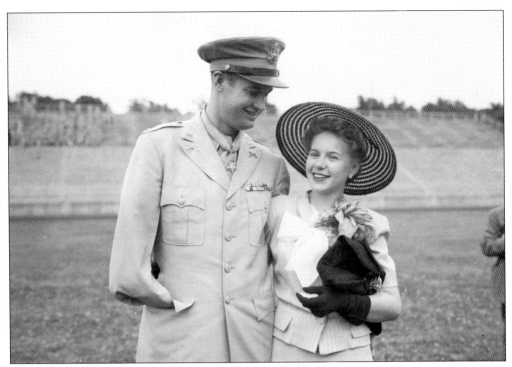

Maurice Lee "Footsie" Britt lettered in football and basketball at the U of A and was a member of Sigma Chi fraternity. He was also sports editor of the student newspaper, the *Arkansas Traveler*, and graduated with a degree in journalism in 1941. He played football for the Detroit Lions for less than a year before he was drafted into the Army. Britt is pictured with his wife, Nancy, and surrounded by football players on June 5, 1944, the day he received the Medal of Honor in a ceremony at Razorback Stadium. Britt went on to serve two terms as lieutenant governor of Arkansas from 1966 to 1970. (Above, MS L541, Image 798; below, U.S. Army Signal Corps photo by Nathan Cutler, Picture Collection 2070a.)

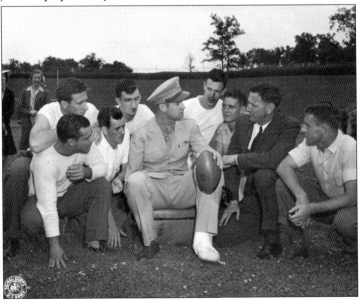

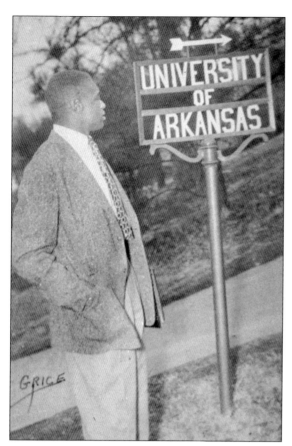

Silas H. Hunt is recognized as the first African American student to be admitted to the University of Arkansas. He was admitted to the law school in 1948, making Hunt the first black student to be admitted to an all-white Southern university. Hunt only attended one semester before becoming gravely ill with tuberculosis. He died in 1949 but not before he broke the color barrier at the U of A. (Photograph by Geleve Grice, MC 1463.)

Robert A. Leflar received a bachelor of arts degree from the University of Arkansas in 1922. In 1927, he became an instructor of law. In 1943, he became the second dean of the law school and was dean during integration. He wrote a history of the university, *The First 100 Years: Centennial History of the University of Arkansas*. Leflar is pictured here examining his latest book in 1978. (MC 1302, 1978-13.)

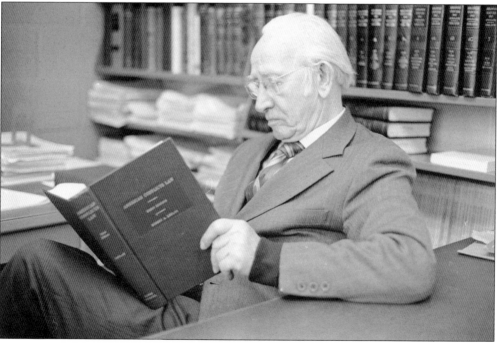

Julian S. Waterman established the law school in 1924 and served as its first dean, from 1926 to 1943. Previously, he served as an economics professor from 1914 to 1922 before taking time off to earn a law degree from the University of Chicago. Later, he served as vice president of the U of A from 1937 to 1943. (Picture Collection 889.)

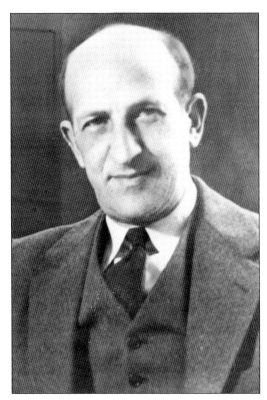

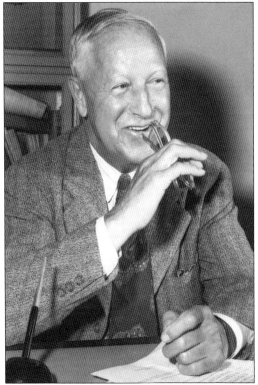

William S. "Pop" Gregson served in multiple capacities at the university from 1919 to 1947, including secretary of the Young Men's Christian Association (YMCA), secretary of student employment services, secretary of the student union, director of religious activities, acting dean of men, professor emeritus, and university chaplain. Gregson Hall was named for him. (Picture Collection 345.)

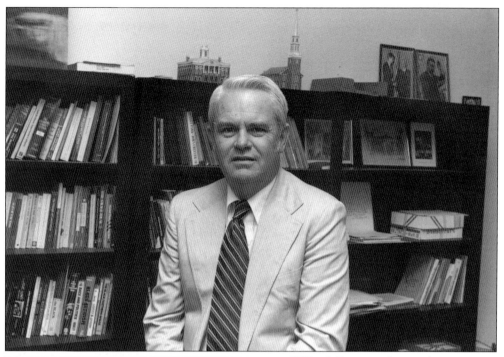

Willard Gatewood served as chancellor from 1984 to 1985. During that period, he established the prestigious Sturgis Fellowships and initiated the restoration of Old Main, resisting calls to demolish it due to safety concerns. A Distinguished Professor of History, Gatewood is also credited, along with Miller Williams, with founding the University of Arkansas Press in 1980. Gatewood retired from the university in 1998. (Photograph by Andy Lucas, MC 2052.UA.)

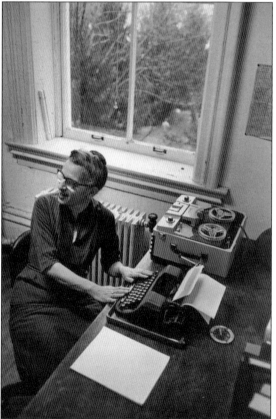

Mary Parler, seen here in her office around 1955, arrived at the university in 1949. Though often overshadowed by her folklorist husband, Vance Randolph, Parler made significant contributions to the preservation of Ozark culture in the collection of over 3,600 songs through her Arkansas Folklore Research Project. She, along with Randolph and others, founded the Arkansas Folklore Society in 1949. Parler taught folklore and literature until her retirement in 1975. (MC 896.)

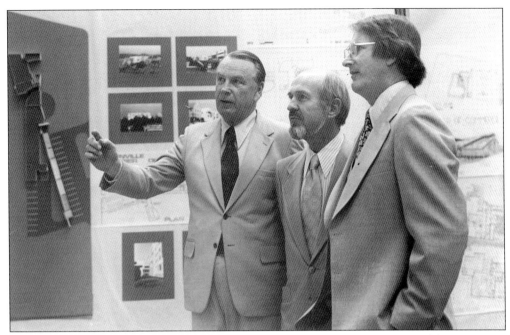

Three leaders and influential men of the architectural program are pictured here in 1975. From left to right are John G. Williams, E. Fay Jones, and C. Murray Smart Jr. Williams founded the architecture department in 1946, and Jones served as the first dean when the department became the School of Architecture. Smart served for 15 years as the school's second dean. (MC 623, Image 30.)

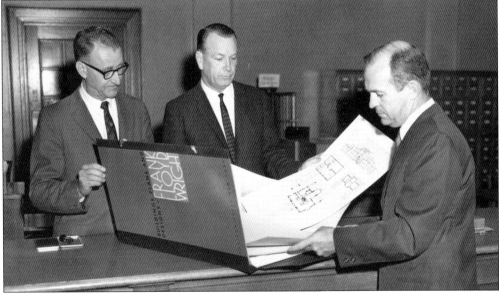

Pictured around 1964 from left to right, library director Marvin Miller, architecture department chairman John Williams, and architecture professor E. Fay Jones examine an acquisition of a Frank Lloyd Wright book, which was added to the library as the 500,000th volume. Jones was an apprentice of Wright, a member of the Taliesin Fellowship, and was influenced greatly by the principles of organic architecture. (Picture Collection 1432.)

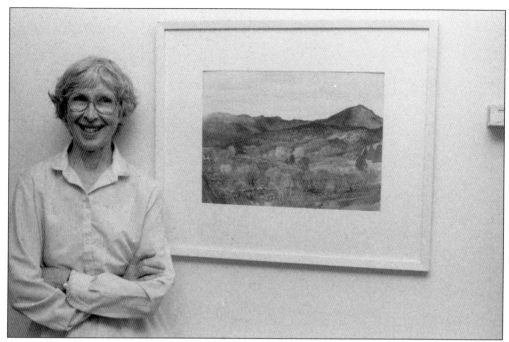

Neppie Connor joined the faculty of the art department in 1946 and served as chair of the department twice. Connor was also an active artist and exhibited her work in Memphis, Tennessee; Little Rock, Arkansas; Oklahoma City, Oklahoma; Dallas, Texas; St. Louis, Missouri; Kansas City, Missouri; New Jersey; and New York. She retired from the department in 1984. Connor is pictured here with one of her paintings in 1984. (MC 1302, 1988-115.)

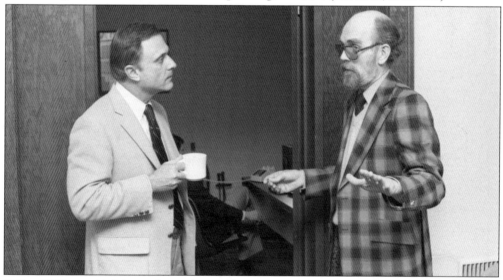

Miller Williams (right) speaks with David Pryor in 1983. Williams began teaching in the English department in 1970. Later, he directed the creative writing program and founded the translation program. He cofounded the University of Arkansas Press with Willard Gatewood in 1980 and became the first director. Williams wrote 37 books of poetry, fiction, criticism, and translation and wrote and read a poem for the second presidential inauguration of Bill Clinton. (MC 1302, 1983-108.)

Loy Barton, shown here with his transistor recorder around 1953, graduated from the university in 1921 with an engineering degree. In 1925, he built KUOA, located in the south tower of Old Main and the first radio station in Fayetteville. Later, he worked for Philco and RCA and developed standards for AM-radio modulation schemes. During World War II, he fine-tuned the art of underwater sonar. (MC 1849, File 7.)

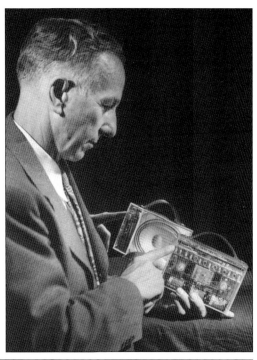

Ken Hatfield played on the national championship football team in 1964 and was also a member of ROTC. He is pictured receiving a medal and saber from U of A president David Mullins for contribution as ROTC brigade commander. Hatfield would later serve as the head football coach at the U of A from 1984 to 1989, and his teams won back-to-back Southwest Conference championships. (Picture Collection 2275.)

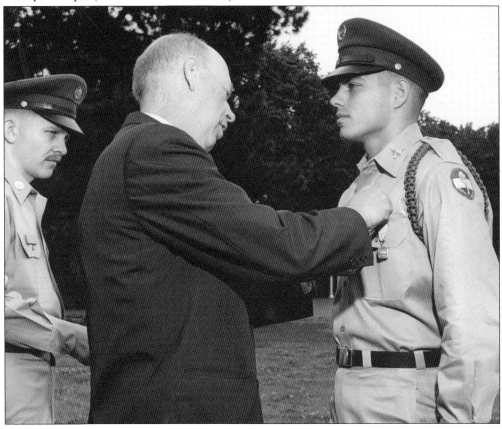

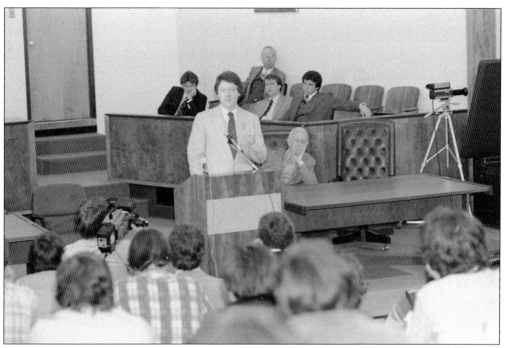

Gov. Bill Clinton's visit to the university's law school in March 1980 is documented in the photograph above. Clinton had taught at the law school in 1973, but he soon moved to Little Rock after his successful bid for Arkansas attorney general in 1976. Two years later, Clinton became the youngest governor in the nation and would eventually serve four more terms before his election to the office of president of the United States in 1992. Hillary Clinton, at left, also briefly taught in the university's law school in the mid-1970s before working at the famed Rose Law Firm and serving as first lady of Arkansas, New York senator, and secretary of state. During their time in Fayetteville, the Clintons forged strong friendships, most notably with Diane Kincaid Blair. (Above, MC 1302, 1980-37; at left, MC 1302, 1976-27.)

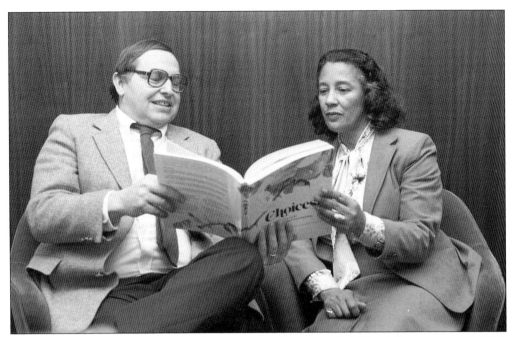

Prof. Margaret Clark poses with John Harrison, director of Mullins Library, around 1986. Clark is an alumnus of the U of A and the first African American female professor, teaching from 1969 to 1998 in the foreign languages department. Clark served as the cosponsor for Kappa Iota, the campus chapter of Alpha Kappa Alpha Sorority, and served as sponsor of the African Student Union. (MC 1302, 1986-20.)

Diane (Kincaid) Blair began a successful career in the political science department in 1968. She remained with the university until her death in 2000. On February 14, 1975, Kincaid (far left) participated in a debate on the Equal Rights Amendment with Phyllis Schaffley (second from right) in the Arkansas General Assembly. Kincaid took the "pro" position and was praised for her excellent debate skills, despite the amendment's failure. (MC 1632.)

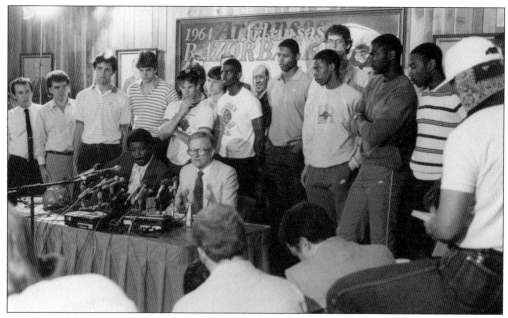

Nolan Richardson is pictured during the announcement of his appointment as head basketball coach on April 9, 1985. He held this position until 2002, winning more games than any other Arkansas basketball coach: 389 wins to 169 losses. Richardson is the only coach to win the Junior College National Championship, the NIT Championship, and the NCAA Tournament. He was inducted into the National Collegiate Basketball Hall of Fame in 2008. (Picture Collection 4602.)

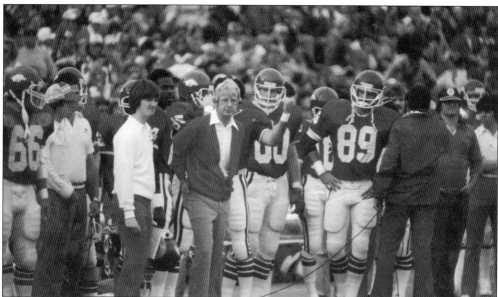

Lou Holtz (plaid pants) is seen here on the sidelines of a Razorback football game in the 1980s. Holtz served as head football coach of the Razorbacks from 1977 to 1983. He took the team to six bowl games and won three, including the Orange Bowl in 1978 against the Oklahoma Sooners, who were favored to win the national championship that year. The fans threw oranges onto the field after the upset. (MC 589, Image 432.)

Frank Broyles looks through the 250 condolence letters he received in January 1966 after the end of a 22-game winning streak, the longest in Razorback history. The streak started on November 23, 1963, and the team would not lose until January 1, 1966. Broyles came to Arkansas in 1958 and served as head football coach until 1976. He served as athletic director from 1973 to 2007. (MC 2016.)

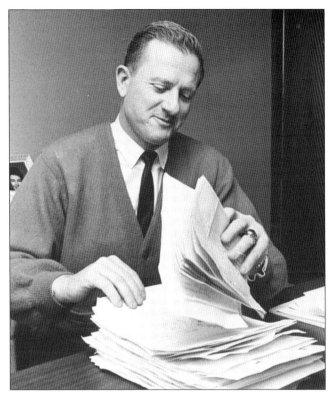

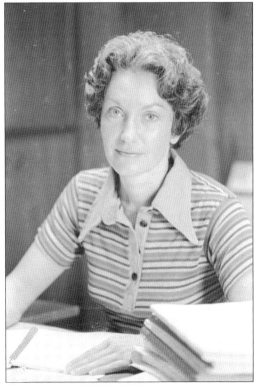

Ruth Cohoon came to the U of A as a swimming instructor in 1965. In 1972, she was appointed the first director of women's intercollegiate sports. Although her administrative duties continued to increase, Cohoon never gave up teaching. She consistently worked to improve women's athletics by seeking better funding, equipment, and scholarships. Cohoon stepped down from her administrative position in 1989 but continued to teach until 1999. (MC 1302, 1977.)

From left to right, Byrne Blackwood, Cleveland Harrison, Donald Harington, and Lowell Fenner perform in the 1958 production of the play *My Three Angels*. A faculty member teaching art history at the U of A for 22 years, Harington was best known for his novels set in the fictional Arkansas town of Stay More. Harrison taught at Auburn University after leaving Arkansas, while Fenner and Blackwood enjoyed successful academic careers as well. (MC 1869.)

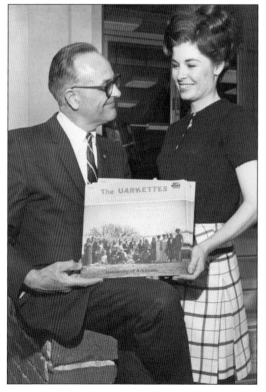

Donna Axum Whitworth holds an Uarkettes record next to Kenneth Ballenger. Whitworth is a celebrated member of Delta Delta Delta. She was crowned Miss America in 1964, the first from Arkansas. Whitworth went on to have a successful career in teaching and journalism in addition to her long list of community service. Whitworth has also been an active alumna, including establishing an endowed scholarship for Arkansans with financial need. (Picture Collection 2186.)

David W. Mullins was president of the
U of A from 1960 to 1974. He was also a
graduate of the U of A in 1931. During
his presidency, the university grew
substantially in physical size, adding
many new buildings. The student
population grew as well; within a
decade, student enrollment doubled.
(Picture Collection 612.)

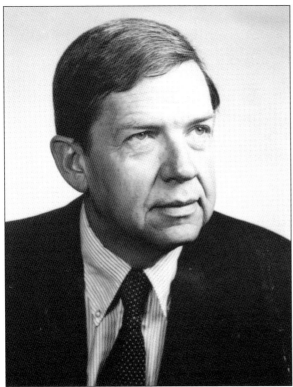

Bill Allen Nugent served as the
first chancellor of the U of A
Fayetteville campus. He served in
this position from 1982 to 1983.
As the U of A grew, Pres. James
E. Martin oversaw the creation of
the office of the chancellor so that
the president could concentrate
on U of A System business from
all of the different campuses,
and the chancellor could focus
on the flagship campus. (MC
1302, 1981-208.)

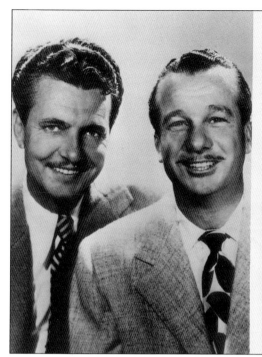

Chester Lauck (left) and Norris Goff transform themselves into the radio comedy duo Lum and Abner. Both actors attended the University of Arkansas in the mid-1920s. Lum and Abner were popular personalities on the radio from 1931 to 1954. The show centered around the fictional town of Pine Ridge, Arkansas, and the eccentric cast of characters patronizing the Jot 'em Down Store owned by Lum Edwards and Abner Peabody. (MC 1356, Image 381.)

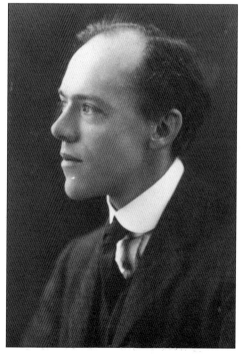

After briefly studying at Harvard University, John Gould Fletcher, pictured here in the early 1900s, sailed to Europe in 1908, where he became involved with the Imagist poets. In 1939, Fletcher was awarded the Pulitzer Prize for Poetry for his work *Selected Poems*. In 1949, Fletcher was appointed writer-in-residence at the university. He helped establish the Arkansas Folklore Society and served as its first president. He died in 1950. (Picture Collection 4261.)

Three

CAMPUS LIFE

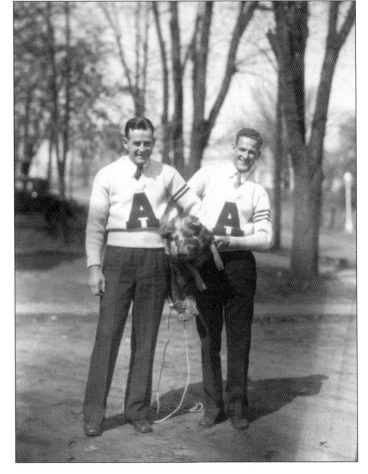

Campus life can
encompass a great deal
more than classes,
especially for the
students who live, eat,
or work there. Campus
life also includes
student clubs, sororities,
fraternities, athletics,
and homecoming
celebrations. Life on
a college campus
is rarely dull and
often unexpected,
as illustrated by this
photograph of Milan
Creighton (left) and
Clarence Geis holding
a pig in 1930. (MS L541,
Image 664.)

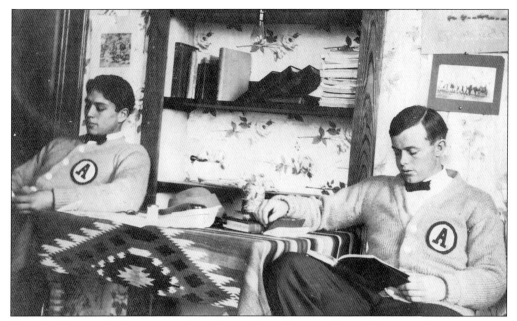

Dormitories are the home away from home for college students. For more than a century, students have worked to personalize their dorm rooms and bring some comforts from home. Pictured here in 1909, Stanley Phillips and Billie Nelson are seen wearing their letterman sweaters while reading in their dorm room in Gray Hall. (MC 589, Image 419.)

This image by the Grabill photography studio again shows two male students who appear to be studying in their dormitory about 1910. The students have personalized their room with pictures hung on walls while their steamer trunks are pushed to the sides. The three male dormitories on campus at this time were Buchanan Hall, Hill Hall, and Gray Hall. All three shared one bathhouse. (Picture Collection 4198.)

These two bobby-soxers giggle in their dormitory room in Carnall Hall shortly after the building was renovated in 1940. Carnall was the first women's dormitory on campus, built in 1906. It was situated on the opposite side of campus from the men's dormitory buildings. (Picture Collection 1015.)

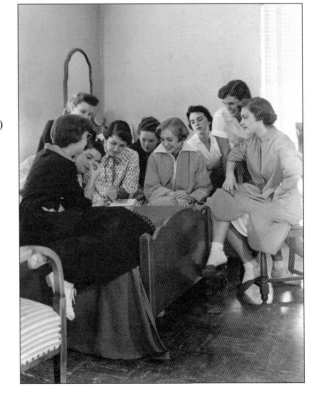

Freshmen women huddle together in Holcombe Hall after orientation in 1954 and look through the annual to learn names. In 1954, Holcombe Hall had 170 residents on the campus of 4,034 students. Holcombe Hall was built in 1948 and named for Jobelle Holcombe. (Picture Collection 2115.)

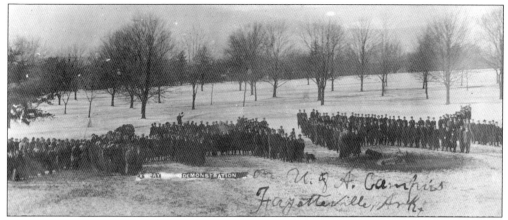

Students spell out "X-Ray" on the Old Main lawn after a protest march. The *X-Ray* was an unofficial paper distributed by students on February 24, 1912, calling for many changes at the U of A. All 36 students who produced the publication were expelled, and all but seven of the student body, then consisting of 724 students, boycotted classes until all 36 students were readmitted. They were readmitted on March 2. (Picture Collection 2750.)

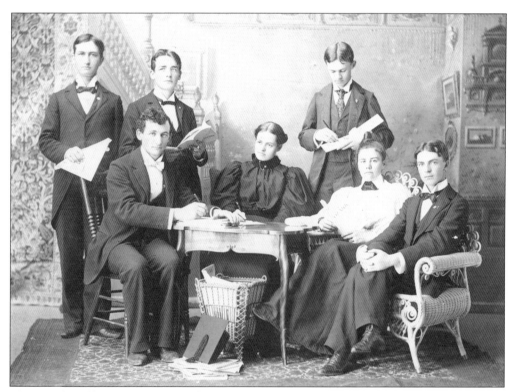

The *Ozark* staff poses here in 1896. Pictured from left to right are (seated) George Vaughn, Clara Earle, Gertrude Gunter, and Marcus Lafayette Bell; (standing) James Mitchell, Richard Nelson Graham, and George Nichols. The *Ozark* was a campus publication that came into existence in 1895. It was previously called the *Arkansas University Magazine*, established in 1893. The *Ozark* continued to be published until 1901. (Picture Collection 1882a.)

The U of A Xi chapter of Kappa Sigma was established in 1890, making it one of the oldest fraternities on campus. A number of prominent Arkansans have been members of Kappa Sigma, including Arkansas secretary of state Claris G. "Crip" Hall, Congressman Bill Alexander, world-famous architect Fay Jones, and Olympian Clyde Scott. Pictured here are the Kappa Sigmas in 1903. (Picture Collection OV3-44.)

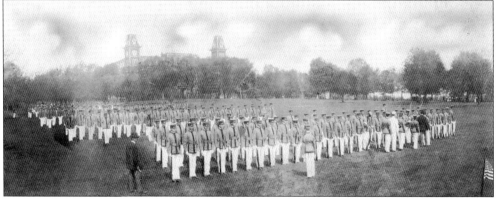

Student military trainees undergo inspection before Old Main in 1908. Instruction in military tactics was one of the requirements for universities started under the Morrill Land-Grant Act and compulsory for all male students starting with the beginning of the university. A military course was a requirement until 1969, when it was made voluntary. (MS R33, Image 16.)

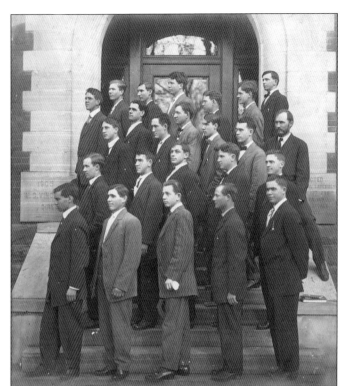

The Agricultural Society was a student group formed in 1908. The society was established to create a larger interest in agricultural work and research at the university and stimulate investigation and knowledge into topics outside of coursework. The group also coordinated social activities and provided a means for discussing issues specific to agriculture students. Pictured here is the Agricultural Society around 1908–1911. (MC 1157, Image 27.)

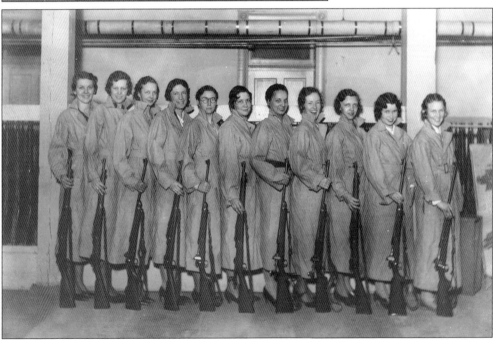

The women's rifle team poses for a photograph in the 1930s. The team was first organized by military art students Franklin Wintker and O.J. Henbest, who assisted Captain Thompson in instructing the team. The women practiced at the indoor rifle range under the stage of the Greek theater. (MS L541, Image 413.)

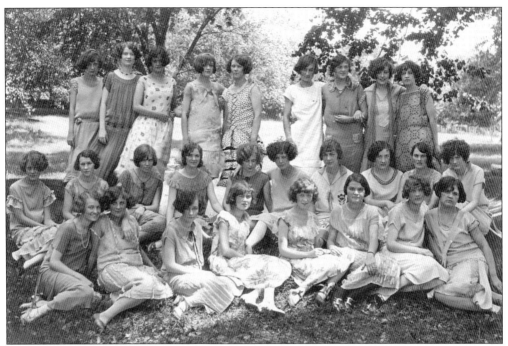

Delta Delta Delta members pose for an informal group photograph in 1923. The Delta Iota chapter of the U of A was incorporated into the national sorority Delta Delta Delta in 1913. It was the fourth sorority on campus. Prominent alumnae include aviator Louise McPhetridge Thaden, Arkansas poet laureate Rosa Zagnoni, and Miss America 1964 Donna Axum. (Picture Collection 5216.)

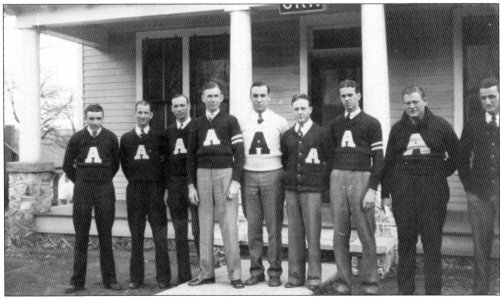

Nine members of Theta Kappa Nu are pictured here in front on their house in their letterman sweaters around 1929. Theta Kappa Nu was a fairly new fraternity at this time. The Arkansas Alpha chapter was established at the U of A in 1926. The national fraternity had only been established in 1924 in Missouri. (Picture Collection 3635.)

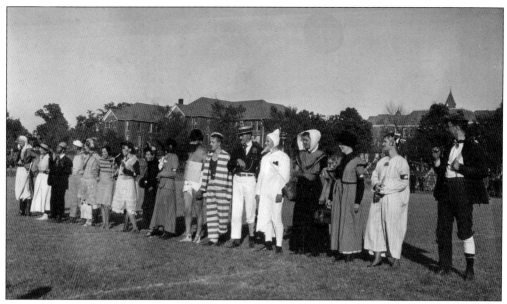

These freshmen students are being paraded onto the football field during halftime of homecoming in the 1930s. The tradition of this freshmen entertainment started in 1918. Because the team usually won on the day of this spectacle, the tradition was made a part of the homecoming entertainment, starting with the first homecoming game in 1922. (MS L541, Image 1051.)

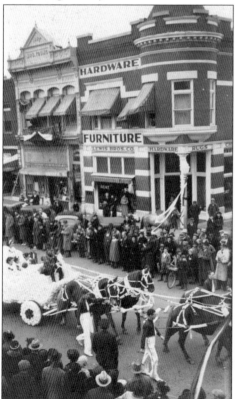

William S. "Pop" Gregson organized the parade for the first homecoming, and there has been a parade ever since. In this c. 1935 photograph is a horse-drawn float in the homecoming parade at the corner of Center and Block Streets. The parades started out with horse-drawn floats and graduated to motorized vehicles but reverted back to horses during World War II to save gas. (MS L541, Image 1050.)

Homecoming queen Jimmie Lou Anderson presides over her court during the 1953 homecoming parade. While the football team lost to the University of Texas, there were many other fun activities, including a pep rally, dance, and reunions. The homecoming maids for this year were Katy Jo Bachelor, Roxanne Carter, Betty Ann Johnson, Peggy Rogers, Charlotte Smith, and Zeda Trull. (Picture Collection 2226.)

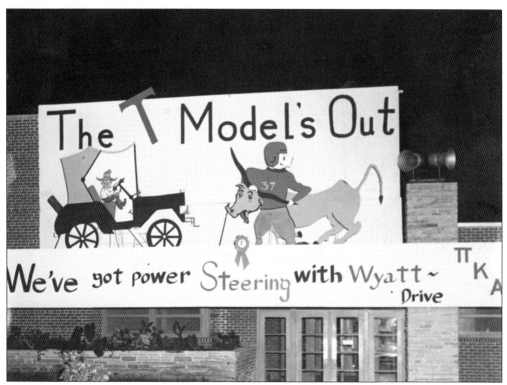

The Pi Kappa Alpha fraternity house is pictured here with the winning house decorations for the 1953 homecoming celebrations. The fraternity also celebrated its 50th anniversary that academic year. The Alpha Zeta chapter was founded at the U of A on November 1, 1904. Other homecoming events that year included a pep rally, dance, the greased-pig chase, and performances by the drill team and band. (Picture Collection 2213.)

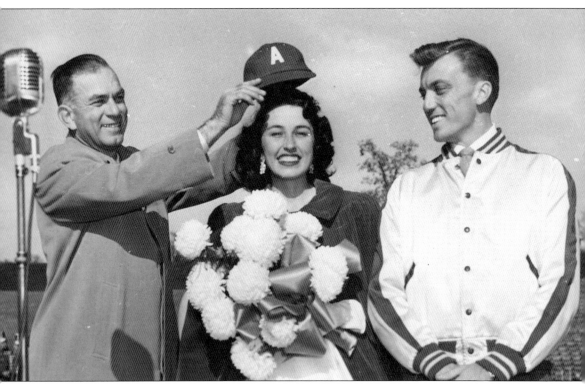

Pictured during homecoming in 1950 are, from left to right, Sen. J. William Fulbright, Betty Jo Simmons, and Bob Wardlow. Simmons smiles despite all the mishaps of the day. Fulbright crowns the homecoming queen with Pop Gregson's red baseball cap when an Arkansas Booster Club (ABC) member failed to produce the crown. Simmons is escorted by Wardlow, president of ABC. Football co-captain Buddy Brown also failed to appear for the traditional kiss of the queen. The game was not any more successful, as the Razorbacks lost to Rice 9-6. Fulbright had a long tradition with the U of A, both as a student and as U of A president. He also had a long involvement with U of A homecomings. Fulbright kicked a field goal to win the first homecoming game in 1922. (Picture Collection 2145.)

This unusual caterpillar parade float by the Chi Omega sorority won first place in the women's division of the float contest for the 1950 homecoming. Two of the homecoming maids that year were members of Chi Omega: Jacque Galloway and Barbara Brothers. Homecoming maids during this time were chosen by the football squad. (Picture Collection 2204.)

Students grease a pig to chase as part of the entertainment during the homecoming football game around 1962. Chasing a greased pig was part of the initiation for members of the Arkansas Boosters Club (ABC) during this time period. It was first performed by freshmen during the 1920s. (MC 2052.UA.)

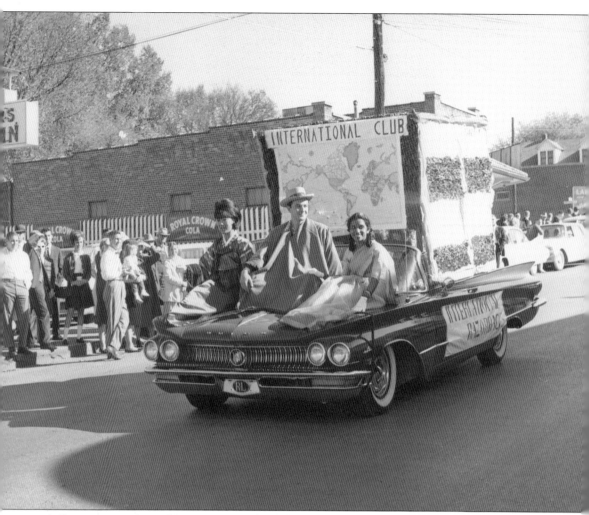

A float representing the International Students Club drives on Dickson Street during a parade in the early 1960s. The university has a long history of supporting students from around the world. The International Club was open to both foreign and native students and provided fellowship and venues to promote greater understanding among all students. Sen. J. William Fulbright was a strong advocate for international education and cultural exchange, and the program that bears his name is a testament to his advocacy. As of 2014, over 119 countries were represented at the University of Arkansas. A number of campus units and groups represent the interests of international students at the university, including Spring International and the Foundation for the International Exchange of Students (FIES). The latter was established in 1949 by a group of faculty members to promote international exchange. Arkansas organizations such as the Pakistan Culture Club, Society of Hispanic Professional Engineers, and Caribbean Students Association offer opportunities to interact with fellow students. The Friends of India, one of the largest cultural groups on campus, hosts the popular annual Diwali celebration. (MC 2052.UA.)

Homecoming floats have always been a creative way to support the Razorbacks and show school spirit. This particular float from the late 1960s features a Texas Tech Red Raider as Little Red Riding Hood approaching a Razorback, which seems to have a hungry look in its eyes. The Razorback is likely pretending to be sick so as to lure the Red Raider closer, where it can devour her. (MC 2016.)

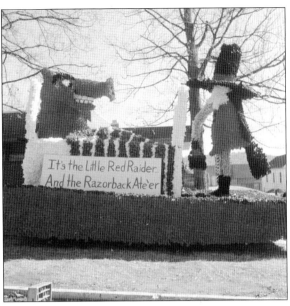

Cheerleaders and majorettes are seen calling the hogs in this c. 1965 photograph by Harold Phelps of the Arkansas Publicity and Parks Commission. The hog call is said to have started in the 1920s, when a group of farmers attending a football game cheered the team on with a hog call. The call was refined into a specific cheer known by people across the state. (Picture Collection 1813.)

This Delta Delta Delta float was in the university's semi-centennial parade in June 1922. The celebration of the school's 50th year was tied in with commencement and also included a reunion, luncheon, ROTC review, the president's reception at the president's home, and a pageant. Special rates were arranged with the railroad for all the people travelling to Fayetteville for the celebration. (MC 905.)

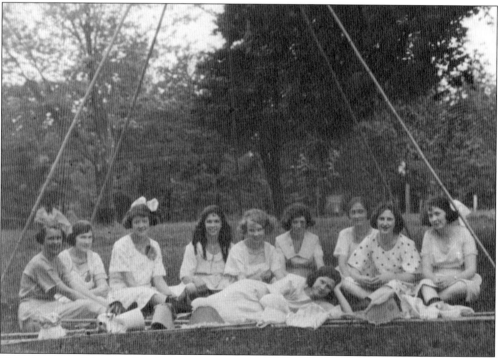

This photograph by Sowder shows a group of women at a spring festival around 1923. There was a May Day festival on May 5, 1923. The festival featured a girls' baseball game, booths for refreshment and games, an outdoor play, a dance exhibition, and the crowning of the May Day queen. (Picture Collection 2266.)

Photographed by Aubert Martin, Tim Bowen and Sterling Cooley were crowned St. Pat and St. Patricia on Engineer's Day in 1952. Engineer's Day began on campus in 1909 around St. Patrick's Day. Events over the years included engineering demonstrations, banquets, dances, and lots of pranks, often involving shamrocks painted in non-washable green paint. The celebration continues today as Engine Week but without the pageants or green paint. (Picture Collection 2658.)

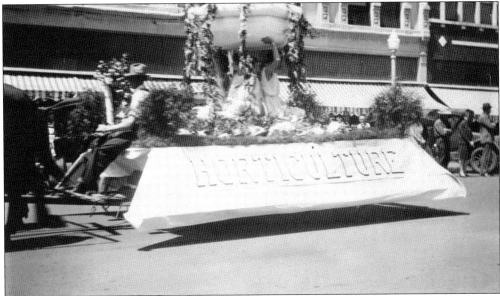

The horse-drawn float of the horticulture department parades around the Fayetteville square for Agri Day on April 26, 1929. The first Agri Day was sponsored by the Agricultural Society and Home Economics Club on the day before Thanksgiving in 1915. The celebration was moved to the spring in later years to take advantage of better weather. Events of early Agri Days included a picnic, parade, and barn dance. (Picture Collection 3631.)

Jack Sigmon and the Arkettes dancers performed at the varsity show in the 1950 Gaebale celebration. Gaebale started in 1947 as a spring celebration to balance the fall homecoming celebration. The word *Gaebale* contains a letter to represent all the colleges and schools on campus. Over the years, the Gaebale celebration included different activities such as dances, concerts, pageants, parades, carnivals, varsity shows, and the spring football scrimmage. (Picture Collection 2668.)

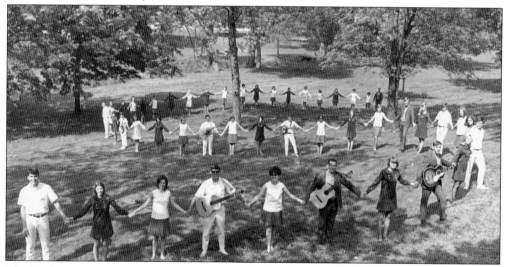

The Uarkettes singing group poses during its 1971 tour through Sweden. The group was established by Prof. Kenneth L. Ballenger at the University of Arkansas in the late 1950s and included Donna Axum, 1964 Miss America, as a founding member. The Uarkettes were invited to perform around the world, from the White House to Europe, and became known as the singing ambassadors for the university.

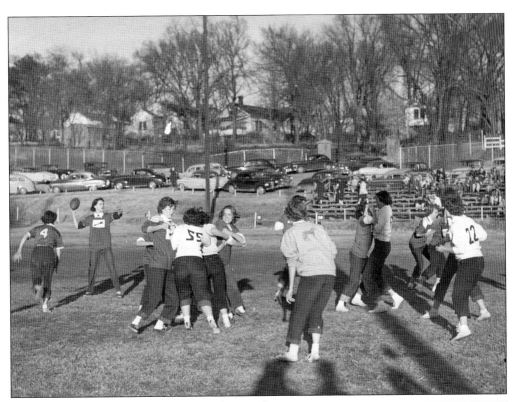

Pi Beta Phi and Kappa Kappa Gamma face each other in the first Powder Bowl in December 1951, drawing a lot of attention on campus. Pi Beta Phi quarterback Barbara Morley is seen throwing the ball to Mary Ann Fletcher. The Kappas scored in the fourth quarter and won the game 6-0. (Picture Collection 2683.)

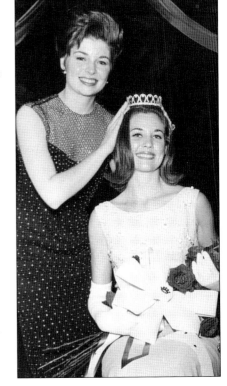

Karen Waldrip receives her crown as Miss University of Arkansas in May 1966 from Donna Axum, who was crowned Miss America two years earlier. The Miss University of Arkansas pageant was held during the Gaebale celebration that year. The winner of the Miss University of Arkansas pageant goes on to compete in the Miss Arkansas pageant. (MC 2016.)

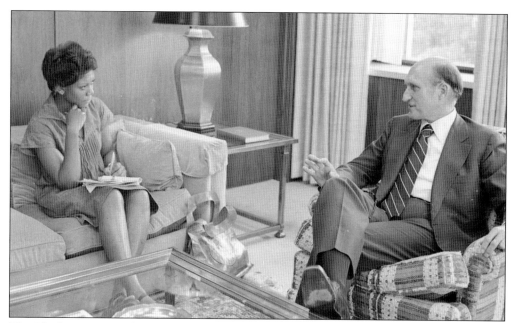

The Black Americans for Democracy (BAD) was the first African American student group on campus. It began in 1968 after the assassination of Dr. Martin Luther King Jr. as a way to unite black students who were still only a small percentage of the campus community. Here, editor Cassandra Smith interviews U of A president Charles Bishop in 1976 for an issue of the newspaper produced by BAD. (MC 1302, 1976-146.)

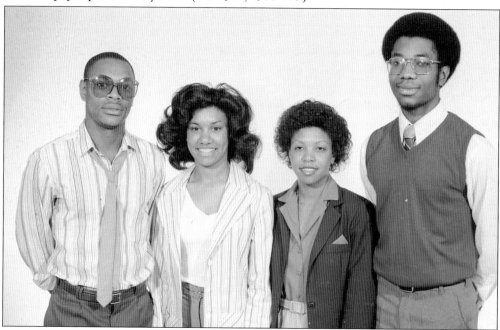

BAD decided in the fall of 1979 to change the name of the group to Students Taking a New Dimension (STAND) in order to promote a more positive image. Pictured here are the STAND officers from 1980. The organization would later change its name to the Black Students Association. (MC 1302, 1980-73A.)

Students are pictured coming and going along the science and engineering building bridge around 1980. The science and engineering building opened in 1964 and was used by students from many different departments. It housed a computer center, electrical engineering shop, the mathematics department, industrial engineering department, zoology department, mechanical engineering department, offices, and laboratories. (Picture Collection 4730.)

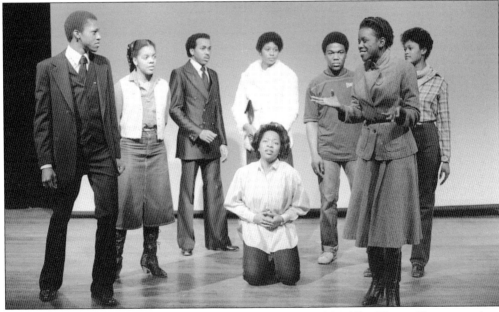

The Ebony Players members are pictured on stage in 1981. The Ebony Players student group was one of the registered student organizations on campus whose purpose was to present African American theatrical plays, skits, and shows. The group did not just perform on campus; the next year, the group traveled to Pine Bluff for an American College Theatre Festival. (MC 1302, 1981-26.)

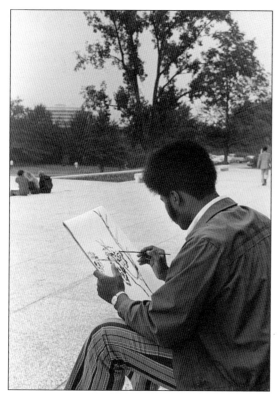

A student is captured sketching on the steps of Mullins Library around 1980. The area between Mullins Library and Arkansas Union, known as the Union Mall, is a hub of activity when classes are in session. It is often filled with student groups and various activities but also with individuals, as seen here. (Picture Collection 4722.)

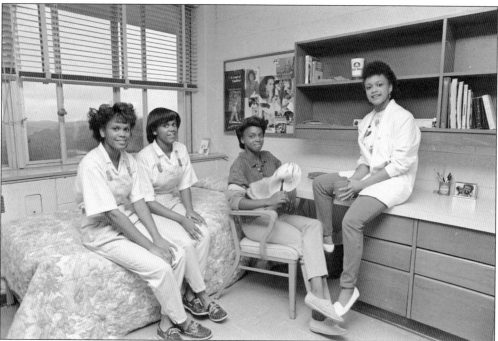

Pictured here is a more modern dorm scene in Reid Hall soon after move-in day in 1987. This dorm room is filled with the Whitby sisters of Brinkley, Arkansas. All four sisters—Anita, Annette, Connie, and Sheryl Ann—attended the U of A at the same time. (MC 1302, 1988-55.)

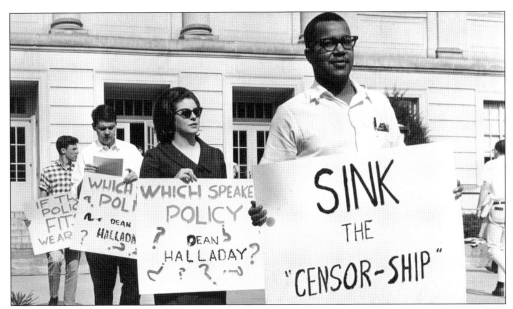

Photographer John Woodruff captured students in May 1965 protesting the suspension of Gary Coe, president of the Off-Campus Men's Club (OCM), and accusing university officials of curbing free speech. After being denied a request by the faculty advisor and a university ban to bring Steven Weissman to campus for a presentation, the group voted the advisor out and proceeded with the planned event. Weissman, a spokesman for the Southern Student Organizing Committee, was considered controversial for his ideas on civil rights, opposition to the Vietnam War, and feminism. His speech drew about 75 attendees. University officials ruled that OCM did not have the authority to oust Lee Schilling as the faculty advisor and suspended Coe for a semester for his role in the affair. Interestingly, other students protested the protestors. (MC 2016.)

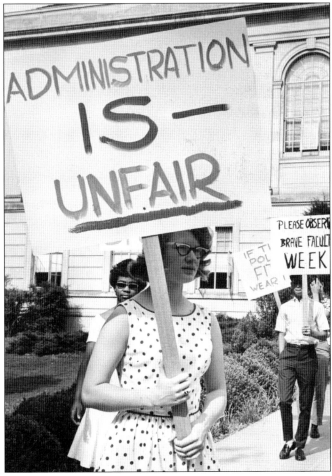

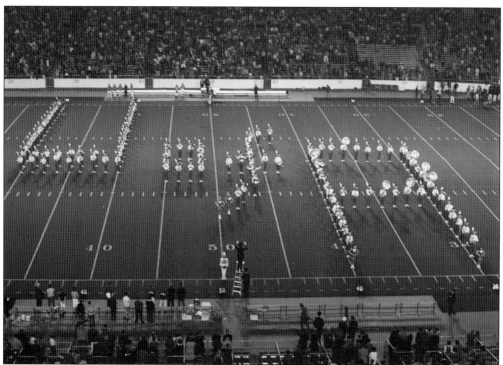

The Razorback Marching Band spells U of A on the football field. The band started forming letters and other formations during halftime under the direction of Francis Judah Foutz, band director from 1928 to 1940. Directly after this time period, the band started changing. With a scarcity of men during World War II, women were allowed into the concert band but not allowed to march. Then, after World War II, former servicemen wanted to participate in the band but did not want to be in ROTC, and a nonmilitary band was formed. Below, the 1976 band members pose for a group photograph. It was during this time period that director Eldon Janzen added the tagline "The Best in Sight and Sound." (MC 2002.UA.)

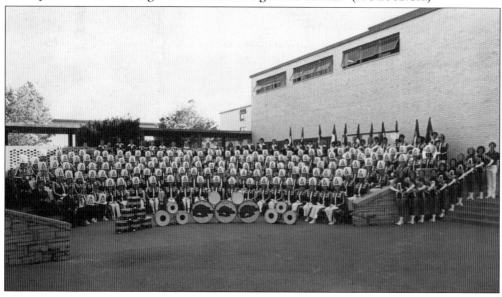

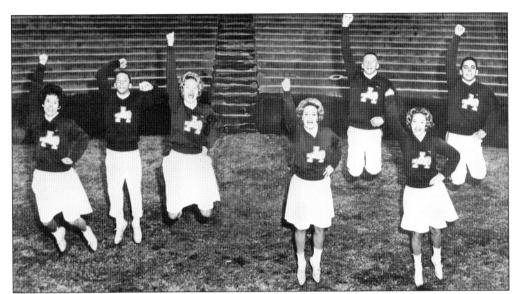

These cheerleaders get their spirit up and practice formations. Cheerleaders have the responsibility of keeping the spirit up of the crowd whether the team is winning or losing. Razorback cheerleaders also have the important responsibility of leading the hog call. Above, from left to right, cheerleaders Madge Gregory of Little Rock, Jim Hinkle of Little Rock, Jenny Mitchell of Fayetteville, Mary Russell of Little Rock, Mickey Miller of Hot Springs, Patty Kelly of Little Rock, and Dwight Holly of Little Rock prepare for the Razorback game in Little Rock against Texas Tech in 1961. At right, cheerleaders practice a pyramid formation around 1977. (Above, Picture Collection 1815; at right, MC 589, Image 174.)

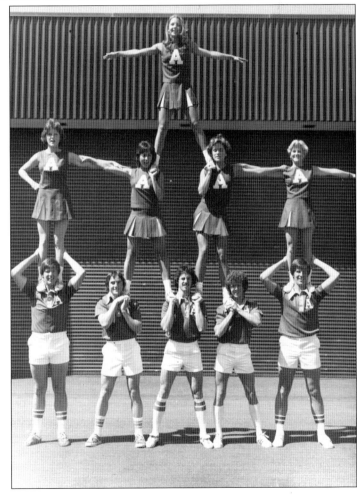

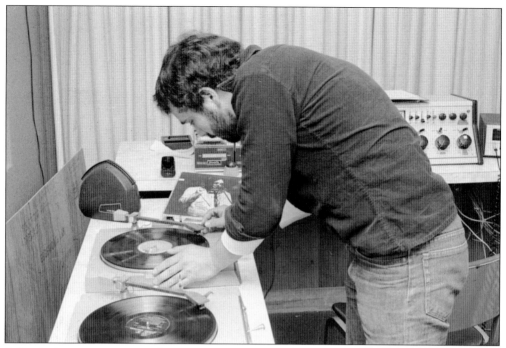

A disc jockey puts on a record at KUAF in 1980. KUAF began as a student radio station with 10 watts in 1973. When a new student station was started in 1985, KUAF became a public radio station, broadcasting NPR news, classical music, and local news programs such as *Ozarks at Large*. KUAF expanded into a 100,000-watt transmitter, covering 14 counties across Arkansas, Oklahoma, and Missouri. (MC 1302, 1980-55.)

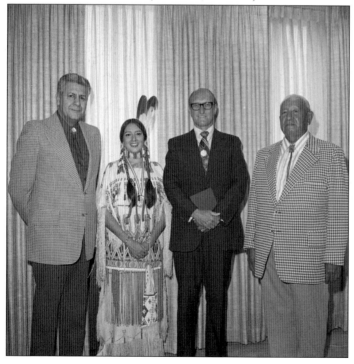

A group of Quapaws presents a medal to President Bishop in October 1975. The woman is wearing traditional Quapaw dress. Quapaws are native to Arkansas, although they were mainly located on the other side of the state from the university along the Arkansas and Mississippi Rivers. The university museum contains some Quapaw artifacts. (MC 1302, 1975-86.)

Four

ACADEMICS

The backbone and core purpose for the U of A is education. Academics play a part in the life of every student. There are common occurrences for every student from registration to commencement; however, each department and college has its own standards, lingo, and celebrations. Pictured here in 1925 is John Clark Jordan teaching a summer school class on the Tau Beta Pi key on the Old Main lawn. (Picture Collection 1884.)

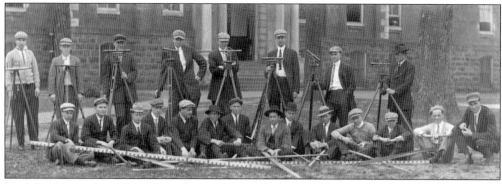

Engineering students line up with surveying equipment in front of Old Main around 1910. The first degree in engineering was awarded in civil engineering in 1888. Engineering classes were originally taught in the College of Liberal Arts, Sciences, and Engineering. A separate College of Engineering began in 1912. (MC 1157, Image 28.)

A group of female journalism students poses for the camera around 1929. From left to right are (first row) Mary Schilling, Nelda Hickman, Zillah C. Peel, Marge Gilstrap, Mabel Claire Gold, and Madge Curtis; (second row) Mary Ellen Fulks, Virginia Reed, Maude Gold, Mary Peel, and Lura Hudson. (MS L541, Image 338.)

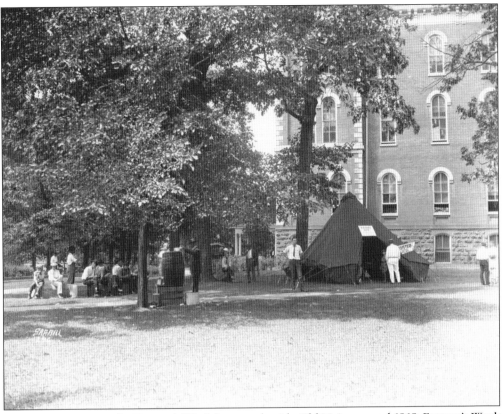

The registration tent for Farmer's Week is set up beside Old Main around 1919. Farmer's Week started around 1919 to share new agriculture methods with the many farmers around the state. Farmers attended lectures and demonstrations and also enjoyed entertainment such as a picnic and barbecue. Attendance reached a high of 6,077 farmers and their families before it was discontinued in 1932 due to budget constraints. (Picture Collection 2120.)

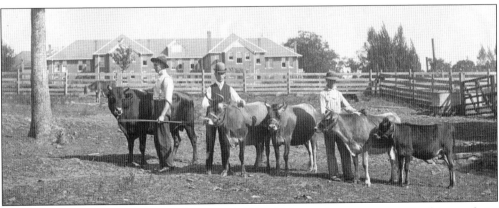

Students display their Jersey cattle around 1910. Male students were required to work on either the university farm or the grounds for three hours every afternoon. Around 1887, as an incentive to encourage agricultural studies, agriculture students were paid 10¢ an hour for this work, engineering students 5¢, and arts and sciences students 3¢. (MC1157, Image 016.)

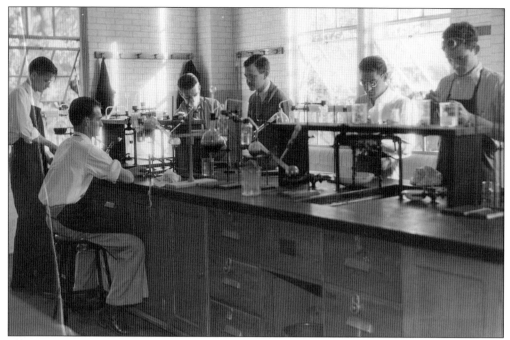

Above, students work in a chemistry lab around 1935. A new and greatly expanded chemistry building was opened that same year. This building is still in use today. Chemistry goes back to the beginning of the university. The first chair of theoretical and applied chemistry, T.L. Thompson, was appointed in 1873, and the first chemistry building was finished in 1905. Below, two graduate students in chemistry make micro-adjustments to a radiation counter. The students are using the instrument to measure the faint radiation from a particle of meteorite as heavy steel slabs and sliding doors keep out the background radiation. (Above, Picture Collection 2708; below, Picture Collection 1834.)

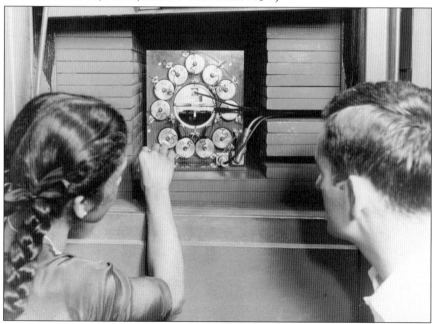

Students work on a project in the University Training School. The training school was derived for university students in the teaching program or normal department to practice teaching. In the early days of the university, the normal department was also in charge of the preparatory department, which prepared students not yet ready for college classes. In 1911, the preparatory department was discontinued, and the training school offered elementary and high school classes. For a time, the whole range from kindergarten through high school was offered through the training school. The upper grades were discontinued first. The elementary school closed in 1966, but the kindergarten remained into the early 1980s. Below, a teacher works with a kindergarten class in 1977. (Above, Picture Collection 1833; below, MC 1302, 1977-65.)

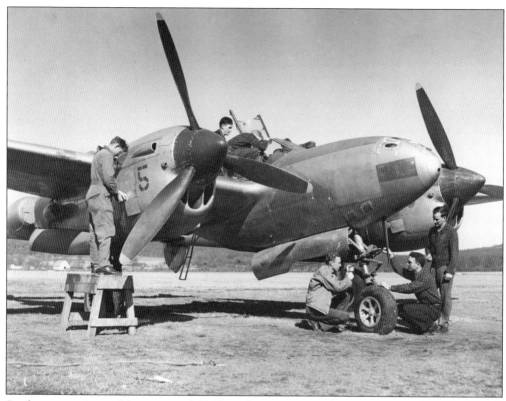

Students are pictured here around 1945 working on a P-38 fighter plane, which was part of the College of Engineering's aeronautical department. The aeronautical program was started by Prof. James G. Gleason in the 1940s as a part of mechanical engineering, but it quickly became its own department. Students studied aircraft engines and aeronautical design and also had flight training. (Picture Collection 1835.)

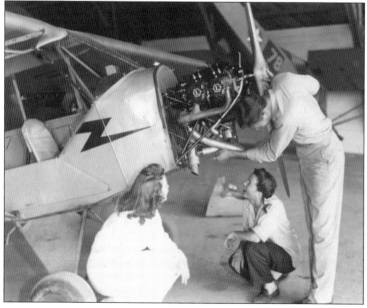

A woman and man examine the engine of a small airplane. While this specific photograph is unidentified, a civilian pilot training course was instituted in 1946 supervised by James G. Gleason and Ray Ellis, manager of the Fayetteville Flying Service. The class prepared students to earn their private pilot certificate through flight training and ground school. (Picture Collection 1869.)

Two students cook on a stove in the food lab, which was part of the home economics program. During this time period, some of the classes available included foods, experimental cookery, and food preservation and demonstration. Home economics was established under the College of Agriculture in 1913. A building specifically constructed for the program was completed in 1939. Home economics evolved into human environmental sciences. (Picture Collection 1859.)

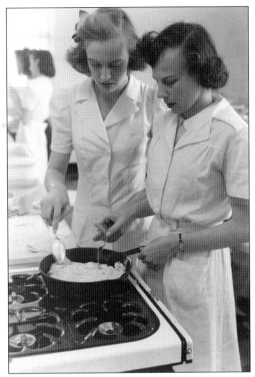

Students learn simple construction and repair in home management under the home economics department. During this time period, students could take classes in household equipment or organization and management of a household. There was also a special practice home where, for academic credit, six girls would occupy the home for a 6 to 12 weeks to practice managing and operating a home. (Picture Collection 1861.)

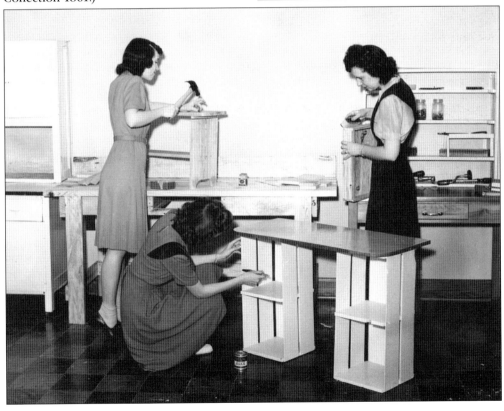

Participants enjoy barbecue during the Chicken-of-Tomorrow Contest. The Chicken-of-Tomorrow program began in 1946 to encourage breeding chickens for superior meat. Pictured here in 1951 is the national contest finals held at the U of A. There was a week of events, including a rodeo, parade, poultry forum, exhibits, tours, concerts, dances, and dinners. (MS L541, Image 1053.)

Tom Cutting and Beloit Taylor enjoy the outdoor picnic at Agri Park in 1956. While the parades of Agri Day were discontinued during World War II, the 1950s brought the addition of a rodeo and saw the creation of Agri Park. Barton Pavilion at Agri Park was completed in 1957 and is still in use. (Picture Collection 2662.)

Being a land-grant institution, the study of agriculture has been an essential feature of the university since the 1870s; it was natural that innovations in farm practices would emanate from the School of Agriculture. A new blackberry picker was introduced in 1965, able to pick one acre of fruit per hour. The machine collected the berries by vibrating the blackberry bushes. (Photograph by John Woodruff, MC 2016.)

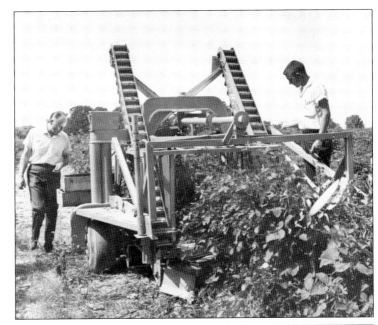

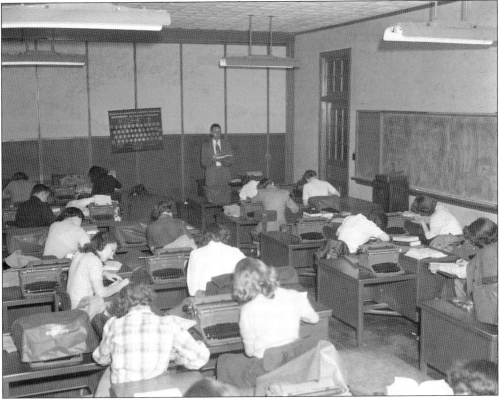

Business students sit at their typewriters in 1951. A business administration program started in 1926 as a two-year course of study for juniors and seniors. It was headed by C.C. Fichtner. By 1937, the program had developed into a four-year undergraduate college. The first business administration building was opened in 1947. (MC 1860.)

Virginia Clayton (right) and an unidentified student are seen block-printing in art class. Art classes were offered inconsistently at the beginning of the university. When David Durst was hired to head the department in 1947, it became a more serious discipline. A revolutionary new fine-arts center was opened in 1950, combining art, architecture, music, and drama all in the same place. (Picture Collection 1823.)

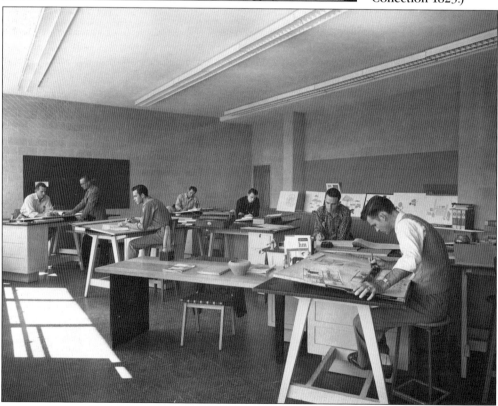

Herb Fowler teaches a class, attended by Warren Seagraves and others, in the new fine-arts center in 1952. Architecture was introduced as a separate discipline in 1947 by John Williams. Previously, architecture classes were taught with engineering classes. In 1953, famed architect E. Fay Jones would join the faculty and later serve as dean of the school. (MC 1674.)

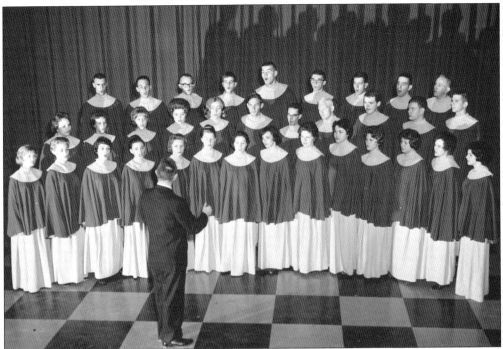

The choir Schola Cantorum is pictured during a performance in 1962. Schola Cantorum is a highly selective choir, although it includes both students majoring in music and students from other disciplines. The choir performs both nationally and internationally, including past performances for President Kennedy and appearances on national television. (Picture Collection 2174.)

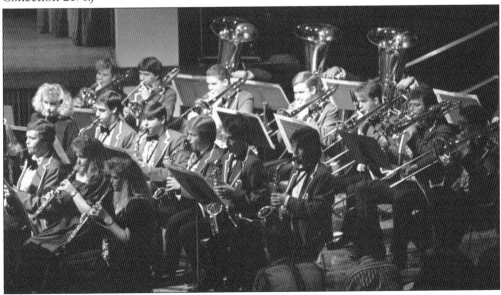

A portion of the symphonic band, which concentrates on classical music, is seen playing a concert in 1989. Though less visible than the marching band, the symphonic band still brings music to a large audience. Today, in addition to the athletic bands, the music department maintains four different concert bands. (MC 1302, 1989-97.)

The Inspirational Singers stand on the steps of Mullins Library in 1981. Now known as the Inspirational Chorale, the group was established to keep alive the tradition of black sacred music. Music professor and Inspirational Chorale director Eddie Jones was instrumental in advancing the choir, which has performed nationally and internationally and is now offered for academic credit. (MC 1302, 1981-209.)

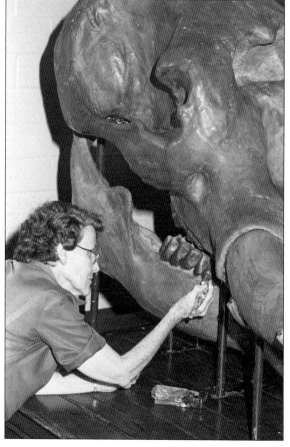

A worker is brushing the teeth of a mastodon at the university museum in 1986. The museum first began in Old Main in 1877. Its artifacts went back and forth between Old Main and Vol Walker Library, along with a few other locations, before landing in the renovated field house in 1985. The museum was closed to the public in 2003, but the artifacts are still maintained. (MC 1302, 1986-252.)

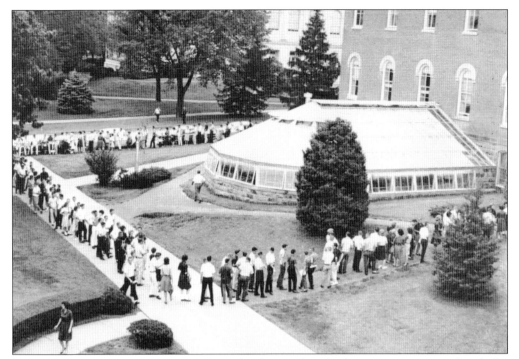

Although registration is mostly conducted online today, the frustration associated with the process most likely has not diminished. Throughout the history of the university, registration has been conducted in various buildings across campus, including the field house and Arkansas Union. In the photograph above, students in the 1960s wait in a line that circles around the back of Old Main to register for classes. By the 1980s, the process took place in Barnhill Arena, pictured below, but it still involved navigating a crush of other students perhaps wanting the same classes and meeting with faculty advisors to decipher the complex schedule. (Above, Picture Collection 4894; below, MC 1302, 197-86.)

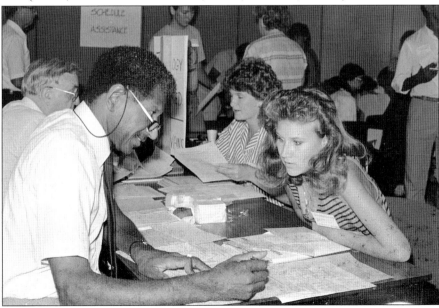

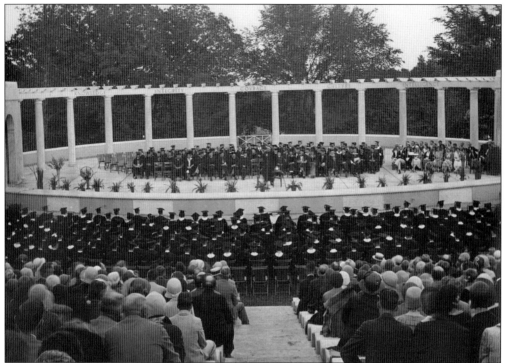

Like the registration process, commencement has taken place in various venues across campus. Students during the 1930s, as seen above, received their diplomas in a ceremony at the Chi Omega Greek Theatre. The setting made for gorgeous views and surely provided many memorable moments, but the stone benches most likely did not provide comfortable seating. In the 1960s, commencement ceremonies were staged in Razorback Stadium, where the students, shown in the photograph below, line up to receive their diplomas. Today, commencement ceremonies are held in December and May to accommodate the large number of graduates receiving degrees. Still, it is impossible to have a university-wide commencement ceremony in May, so the individual colleges hold their own ceremonies at different times, while the master's and doctorate students receive their hoods in Bud Walton Arena. (Above, MS L541, Image 1015; below, Picture Collection 1936.)

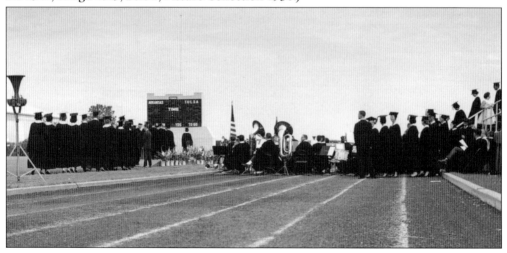

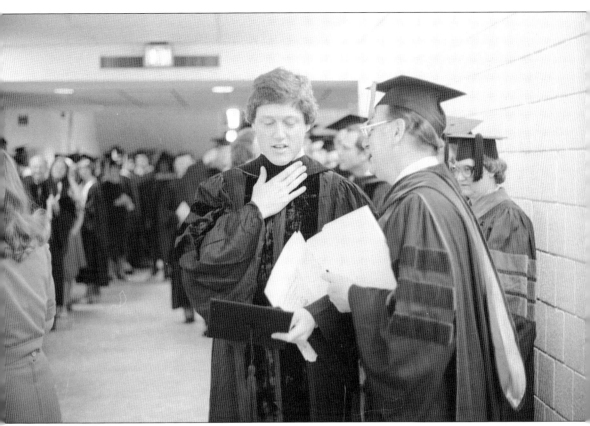

Gov. Bill Clinton gave the keynote address at the 1979 commencement ceremony, which was held in Barnhill Arena. Clinton had taught at the university's law school in the mid-1970s and was elected the state's attorney general in 1976. Earlier in 1979, Clinton had taken the oath of office as governor of Arkansas, and his commencement address was most likely one of his first speeches as governor. (MC 1302, 1979-50.)

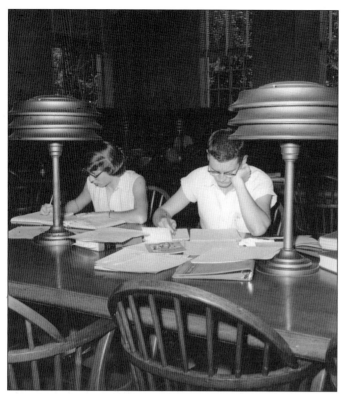

At left, two students are diligently studying in the reading room of Vol Walker Library in 1956. The library has always supported the academic pursuits of the students and faculty by providing resources, space to study, and the expertise of the librarians. Vol Walker provided three reading rooms with seating capacity of 500, along with seating for an additional 100 in other spaces, including a browsing room, seminar room, and 50 cubicles. At its opening, Vol Walker had space for 250,000 volumes. Below, a row of graduate carrels has been photographed in 1942 by Walter Lemke. (At left, Picture Collection 1389; below, Picture Collection 1395.)

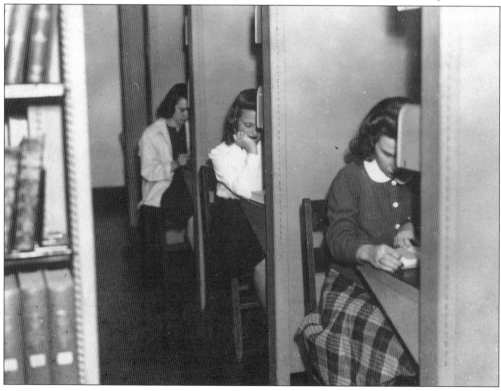

When Mullins Library was built in 1968, it contained study and use space for 1,800 people, more than triple the study space in Vol Walker Library. Pictured here in 1974 is a student in one of the many study spaces. The library underwent an expansion in 1997 and just recently added its two millionth volume. (MC 1302, 1974-49.)

Many researchers would find this room familiar, although the furniture and layout have changed since the 1970s. A division of the university libraries, U of A Special Collections was established in 1967 with the mission of collecting and preserving Arkansas history. That mission remains today, and the facility, the largest academic archives in Arkansas, has diverse holdings documenting the spectrum of the state's history.

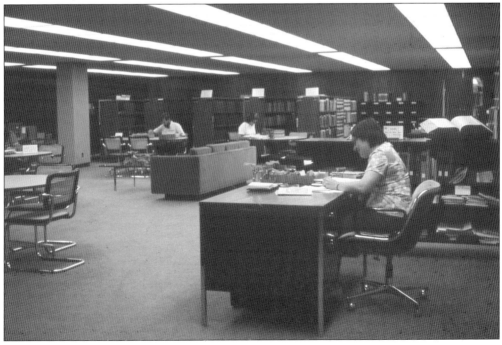

Computers on campus have changed a lot over the years. Pictured here is the G-15 Bendix computer, new for the animal science building in the 1959 academic year. The building was proposed by Lippert Ellis, dean of the College of Agriculture, as a way to combine bacteriology and veterinary science, which for years had been spread around campus. The building opened in 1955. (Picture Collection 2433.)

Students in the mechanical engineering building work with the IBM 370, which was first introduced by IBM in 1970 using techniques for high-performance computers. In 2008, the U of A established the Arkansas High Performance Computing Center, featuring a supercomputer. The computing center is used by multiple departments across campus. (Picture Collection 4728.)

In addition to high-performance computing, personal computers have become more prominent each year, starting in the 1980s. A business student works at a personal computer in 1986. In 1984, the business college installed 21 IBM personal computers in a computer laboratory and then installed another 40 in the college in order to increase computer-based classes. (MC 1302, 1986-114.)

Prof. Franklin Deaver examines an engine with students in the mechanical engineering building around 1980. In 1981, the university, in partnership with the Winthrop Rockefeller Foundation and Cities Service Corporation, started a recruitment program for minority students wishing to become engineers. Part of the program was an intensive eight-week summer program at the U of A. (Picture Collection 4726.)

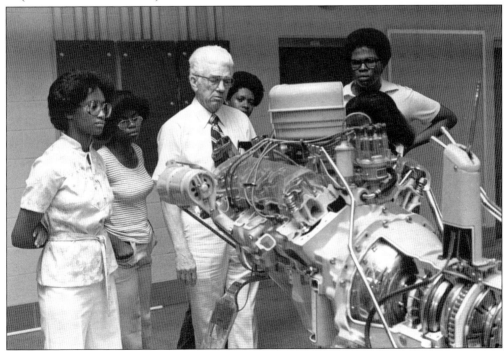

John G. Williams founded the architecture department in 1946, first under the College of Engineering. In 1950, the department occupied space in the fine-arts center designed by architect Edward Durell Stone. In 1968, it moved to the newly vacated Vol Walker building. The School of Architecture was created in 1975 and renamed the E. Fay Jones School of Architecture in 2009. Pictured here is architectural drafting in 1987. (MC 1302, 1987-54.)

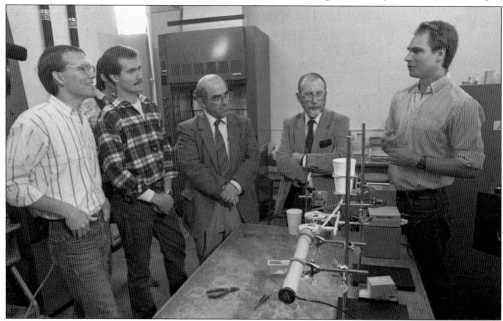

Graduate student David Weeks is seen in a campus lab examining a superconducting motor in 1989 with others from the physics department, including Allen Herman, chair of the department. Physics classes go back almost to the beginning of the university. The 1873 catalog lists a physics class under the engineering program. (MC 1302, 1989-125.)

Five

ATHLETICS

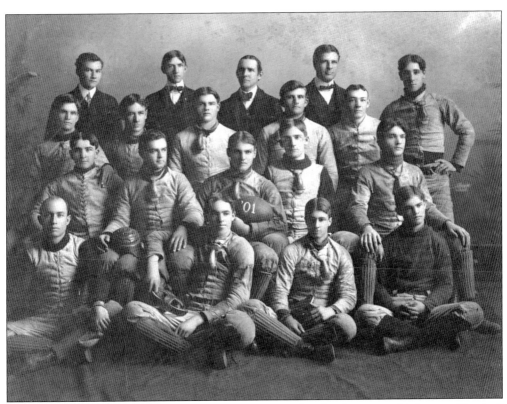

Athletics are a unifying force not just for the campus but for the state of Arkansas. Football is the most popular sport, drawing crowds of up to 72,000, and football, baseball, and track are the longest running sports at the U of A, dating back to the 19th century. The U of A has won National Collegiate Athletic Association (NCAA) national championships in football, basketball, and track. Pictured here is the 1901 football team. (Picture Collection 2024a.)

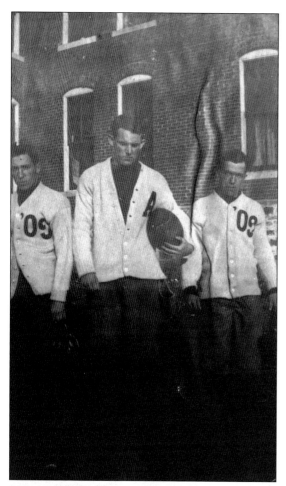

At left are, from left to right, C.R. "Dusty" Rhodes (quarterback), Phil McNemer (fullback), and Joe W. Rhodes (left end), who played on the senior football team in 1909. The senior team played a game against the junior football team on December 11, 1908. The seniors beat the juniors 14-0. The regular football team had a mediocre season that year with an overall record of 5-4, scoring 214 points with 120 points scored against them. The season was clouded by the death of one of the players, Earnest Dickson, who became ill on the way to an away game in Austin, Texas. He was left in a sanatorium there, where he later died. Pictured below are some unidentified football players around 1909. (At left, MC 589, Image 180; below, MC 589, Image 182.)

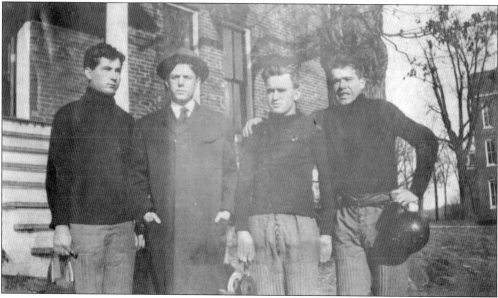

A baseball game is in progress at the athletic park around 1909. The park was started in 1884 when students asked to have 2.5 acres set aside for a football and baseball field. A baseball club was established in 1893. Also during the 1890s, the athletic fields were improved, a grandstand was erected, and the baseball team began to play games away from the university. (MC 1157, Image 30.)

While men's basketball did not begin formally at the U of A until 1922, women's basketball began in 1905 but was discontinued by the administration in 1910. Pictured here is the team from 1907–1908. The members are, from left to right, (first row) Myrtle Johnson and Rose Rollins; (second row) Myrna Glass, Ethel Woodruff, Bess Wolf, and Ressie Lyons; (third row) Nelle Coleman, Maude Ryan, and Katie Sue Moore. (Picture Collection 2339.)

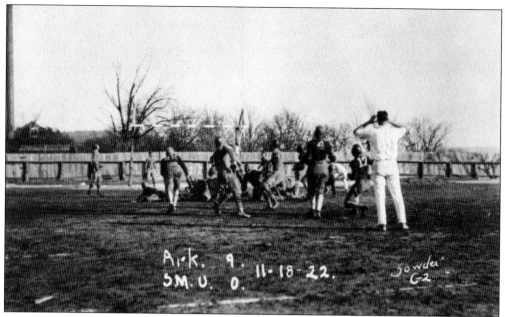

J. William Fulbright, later Senator Fulbright, kicks a field goal during the first homecoming game. The game was played against Southern Methodist University on November 18, 1922. Earlier in the game, Fulbright threw a touchdown pass. The Razorbacks would win the game 9-0. (Picture Collection 3850n.)

The football team for the academic year 1910–1911 was the Southwest champion. The team only lost one game all year, but their scoring record was more impressive: they only gave up 19 points to opponents during the whole of the season while scoring 222 points. (MC 589, Image 183.)

Intramural track goes back at least to 1886 at the university, with official teams following later. Here is the 1911 track team in an image taken by the Grabill photography studio. In the spring of 1911, they competed in two meets, winning the statewide meet in Little Rock. (MC 1157, Image 35.)

Phil McRae was the captain of the track team in 1929. McRae was chosen as captain because of his steady performance and good example in training. The U of A team held meets in 1929 with the College of the Ozarks, Kansas State Teachers, Oklahoma A & M, and Missouri Teachers. (MC 589, Image 406.)

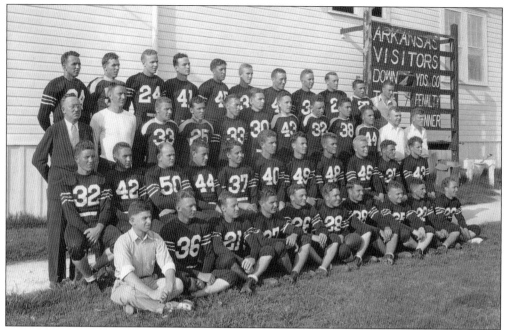

The 1933 football team and coaches pose for a group shot by Walter Lemke. The team was the Southwest Conference leader but not champion because, unbeknownst to the coach, a player who played part of one game was ineligible. The wooden scoreboard with hand-painted letters next to the team is quite a change from today's video scoreboard, which measures 38 feet tall and 167 feet wide. (MC L541, Image 688.)

Football players and soldiers are bundled up on the sidelines in the 1940s. The early 1940s was a challenging time for the football team, as players and coaches regularly joined the armed services. First, coach Fred C. Thomsen, then coach George Cole, and then coach John Tomlin joined the armed forces. After serving, Glen Rose coached for one year before John Barnhill became head coach in 1946. (Picture Collection 2004.)

The press box in 1930s was a simple wooden frame identified as the "radio broadcast booth." Pictured below in the 1950s is the much-expanded press box in Razorback Stadium. A new three-story press box was constructed in 1950 and awarded the Football Writers of America Certificate of Merit in 1956. It had the capacity for around 200 writers, broadcasters, cameramen, coaches, and scouts. It also contained a snack bar and served a full meal to personnel before each game. The press box was expanded again later and renamed Orville Henry Press Row around 2002. Orville Henry covered Razorback football for the *Arkansas Gazette* and the *Arkansas Democrat*. Henry was a sportswriter in Arkansas for six decades. (Above, MS L541, Image 723; below, Picture Collection 2555.)

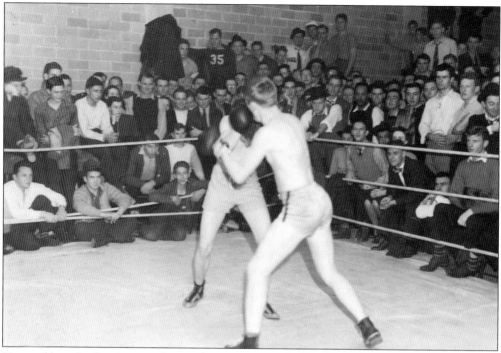

Pictured here is a boxing match in 1940. Boxing and wrestling were intramural sports during this time period, and students representing fraternities or independent clubs competed in the matches. The Dukes Club and the Aces Club were formed in 1940 to give men not in fraternities more opportunities to compete in intramural sports. (Picture Collection 2711.)

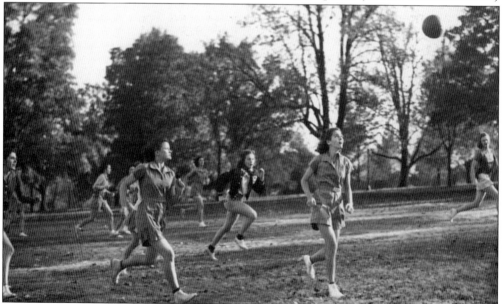

Women play soccer around 1948. During this time period, female students mostly competed in play days, sports days, or physical-education classes. It was not until 1972 that a women's extramural program was funded. Then, in 1979, women's athletics were moved from the College of Education into the athletic department. (Picture Collection 2447.)

The 1955–1956 season started off with the first game in Barnhill Arena on December 1, 1955, with the basketball hogs losing to Southeast Oklahoma by one point. The game pictured here pitted the Razorbacks against the Rice Institute Owls, with Arkansas winning by a score of 84-70. Barnhill served as the home of the basketball hogs until 1993, when the new Bud Walton Arena opened. (Picture Collection 2320.)

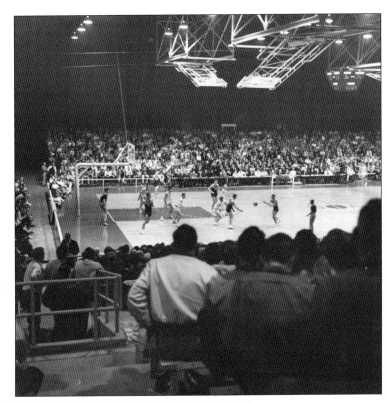

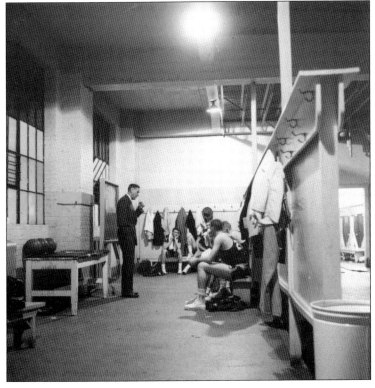

Coach Glen Rose talks to his players during an away basketball game. Glen Rose served as head basketball coach twice, from 1934 to 1942 and 1953 to 1966. During his two tenures, the team won the Southwest Conference three times, tied for first three more times, and went to the NCAA Final Four once. (MC 589, Image 90.)

At left, coach George Bernhardt walks with player George Nesbitt at a game in 1957. That season was the third for head coach Jack Mitchell. The athletic facilities saw improvement, as an additional 5,000 seats were added to Razorback Stadium and a new athletic complex had recently been completed, which comprised the football stadium, basketball arena, track, football practice field, and athletic dormitory, all located together with the baseball stadium only a mile away. Below, four football players from that same year kneel on the field of Razorback Stadium. From left to right are Ronnie Underwood, George Nesbitt, George Walker, and Donald Horton. (At left, MC 589, Image 318; below, MC 589, Image 314.)

Three baseball players watch coach William "Bill" Ferrell get ready to bunt a baseball in the spring of 1953. Unfortunately, the team had a poor season that year, ending with a 7-11 record. Although baseball teams go back to the 1890s at the U of A, there was no baseball team on campus from 1930 to 1947. (Picture Collection 2105.)

The 1957 golf team poses for a photograph. The team started with all new players that year and finished the season fourth in the league. Pictured from left to right are Joe Boone, Ray Barnes, Bobby Waldron, coach Bob Zander, Jerry Breckenridge, Louis Henderson, and Rex Marsh. (MC 589, Image 371.)

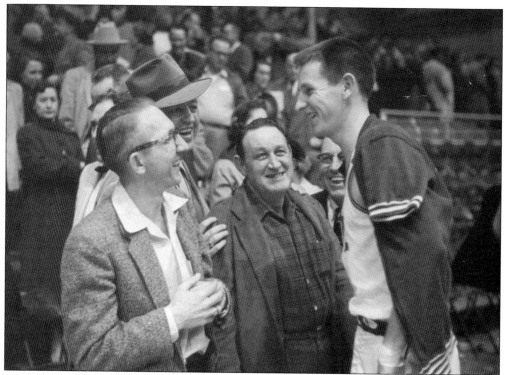

Basketball player Fred Grim of Green Forest talks with fans after a game in 1956. The team finished second in the Southwest Conference that year. In 1958, Grim was co-captain of the team. That season, he averaged 16.8 points per game in conference play and 14.4 points per game. The team tied for first place with Southern Methodist University in Southwest Conference competition. It was the 14th Southwest championship for the team. The Razorbacks were in first place all but five days of the season. Below are members of the Razorback basketball team around 1958. (Above, MC 589, Image 79; below, MC 589, Image 81.)

Head football coach Frank Broyles sits in the bleachers and watches a scrimmage in 1966. Broyles served as head football coach for 19 years, with an overall record of 144-58-5. During his tenure, the team won a national championship in 1964 and seven Southwest Conference championships. Among other honors, Broyles was inducted into the College Football Hall of Fame in 1983. (MC 2016.)

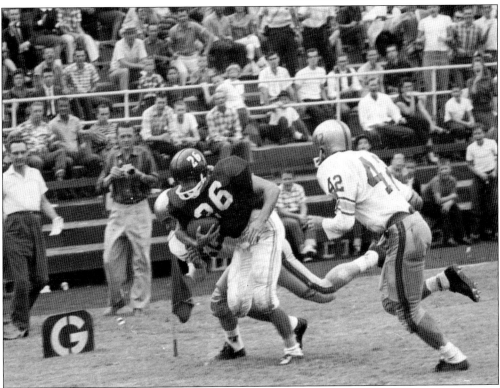

Halfback Jarrell Williams makes a play during the Arkansas-Tulsa game on September 24, 1960. Williams scored a touchdown in the second half, and the Razorbacks went on to win the game 48-7. The team then won the Southwest Conference championship for the second season in a row. (MC 589, Image 328.)

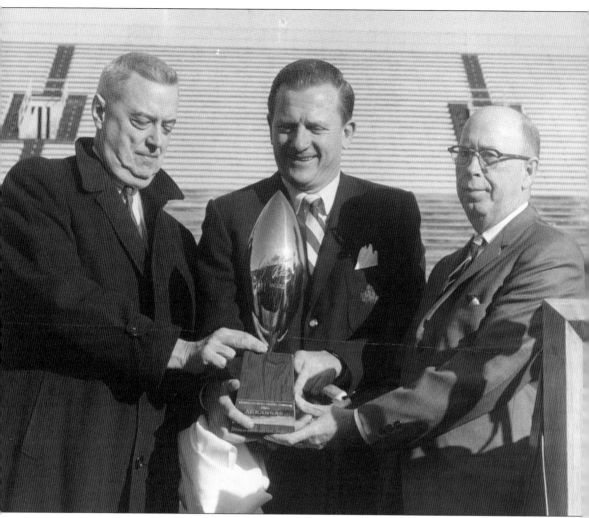

From left to right are Tim Cahone, head football coach Frank Broyles, and U of A president David Mullins. Mullins and Broyles accept the football national championship trophy from Cahone, sports editor of *Look Magazine* for the 1964 season. The championship was awarded in the middle of a record 22 straight wins for the Razorbacks. This is the only national championship won by the U of A in football. This championship was not only important to the U of A, but it also affected the way national championships were awarded. Alabama was named national champion by some polls before the bowl games; however, Alabama lost to Texas in the Orange Bowl, and Arkansas defeated Nebraska in the Cotton Bowl, making Arkansas the only undefeated team in the nation. After this time, many polls began to wait until after the bowl games to name a national champion. (MC 1116, Image 41.)

After Arkansas beat Texas 27-24 on October 16, 1965, the Associated Press College Football Poll named Arkansas the no. 1 team. These Razorbacks are caught in a casual photograph celebrating the ranking. From bottom to top are Mike Jordan, Ernie Richardson, Mickey Maroney and Loyd Phillips (MC 2016.)

Bobby Burnett catches a pass from Jon Brittenum during a practice session for the September 18, 1965, game against Oklahoma State University. It would be the season opener for the defending national champion, which had an undefeated season the previous year. Arkansas won the game 28-14. (MC 2016.)

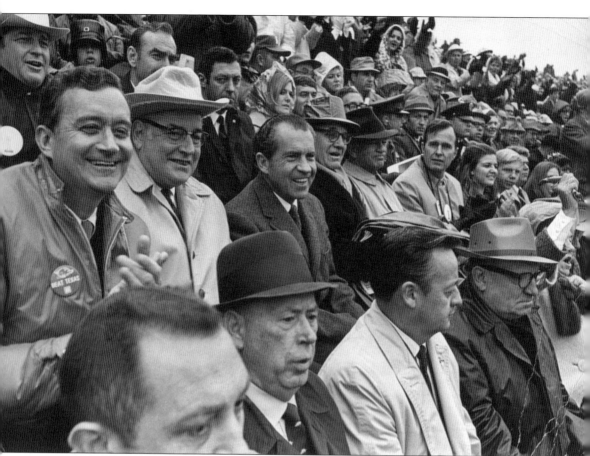

On December 6, 1969, the Arkansas Razorbacks, ranked no. 2 and riding a 15-game win streak, faced the Texas Longhorns, ranked no. 1 and carrying 18 consecutive wins. The Razorbacks and the Longhorns were fierce rivals at the time, with one or the other of the schools winning the Southwest Conference 8 out of 10 previous years. Because of the rivalry, before the season started the game was moved from its originally scheduled time in October to December so that it could be aired on national television. Astroturf was installed especially for the game. It also attracted the famous fans shown in this photograph by White House photographer Oliver Atkins. From left to right are John Paul Hammerschmidt, Winthrop Rockefeller, Richard Nixon, John McClellan, J. William Fulbright, and George Bush. U of A president David Mullins sits in front of Hammerschmidt. *Air Force One* landed in Fort Smith, and then the party travelled to Fayetteville by helicopter. The Razorbacks led 14-0 in the third quarter, but the Longhorns would come back in the fourth quarter to win 15-14. (Picture Collection OV 1-55.)

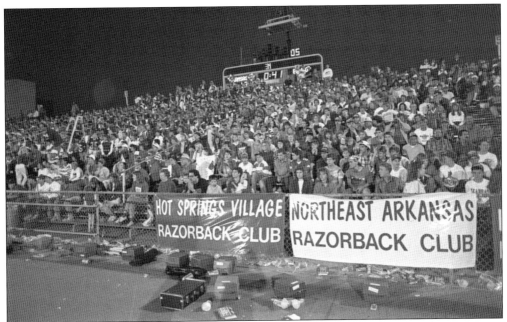

These fans watch the first game with lights in Razorback Stadium on homecoming in 1989. Before the game there was a Bear-B-Que and a pep rally at the Greek theater as the Razorbacks got ready to face the Baylor Bears. The lights were trucked in from Iowa so that the game could be broadcast on ESPN. The teams played in front of a crowd of 51,000, and the Razorbacks won 19-10. (MC 1302, 1989-415.)

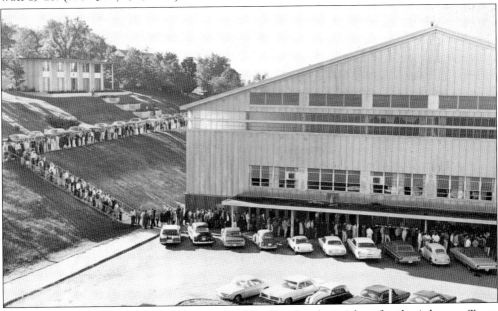

Students stand in a line that stretches around the block to buy tickets for the Arkansas-Texas football game that would take place on October 16, 1965. At the time, Arkansas had won its last 16 games, and Texas, ranked no. 1, had not been beaten since they last played Arkansas. There was a week of activities before the game and more celebration when Arkansas won the game 27-24. (MC 2016.)

Student athletes jump hurdles in a track meet around 1974. During this time, John McDonnell was the assistant track coach. He became the head coach in 1978 and remained in that position until 2008. At that time, he won 40 national championships, more than any other coach in any sport in NCAA history. His teams also won the triple crown five times and 83 conference championships. (MC 589, Image 412.)

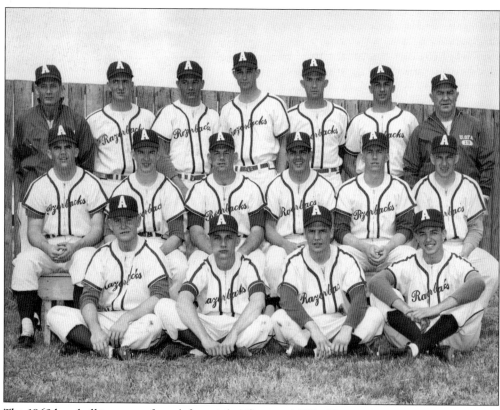

The 1963 baseball team are, from left to right, (first row) Mike Haynie, Jim Bone, Larry Lazecki, and Jim Bane; (second row) Marl Carter, Billy Gray, Lynn Elliott, Ken Hatfield, Paul Soden, and Ted Mont; (third row) coach Duddy Waller, Jim Jay, Jackie Whillock, Jim Magness, Dan Mulhollan, Delano Cotton, and coach Bill Ferrell. (MC 589, Image 5.)

From left to right, Amanda Holley, Connie Fitzgerald, and Bettye Fiscus score a victory in this basketball game with SMU. Bettye Fiscus became the first Lady Razorback to score more than 1,000 points. Though women's basketball started in 1904, administration stopped the sport in 1910, and it would not start again until around 1976. (MC 1880.UA, Image 56.)

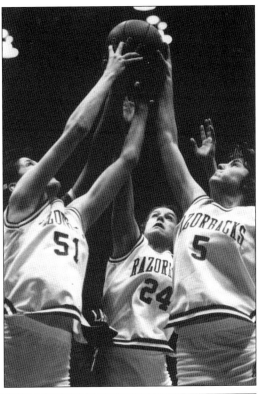

Thanks to Title IX, women's athletics grew in the 1970s, transforming from sports days to extramural program to athletic department. Pictured here is the 1976–1977 Razorback track team. The members are, from left to right, (first row) Carol Ann Riggs, Janet Meyer, Sarah Hensley, Denise Wells, and Ellen Connell; (second row) coach Betty Robinson, manager Sandy Sanders, Kathy Rowland, Ruth Carey, Linda Bedford, Pat Keck, Kelly Elliott, and Lu Ann Huddleston. (MC 1880.UA, Image 151.)

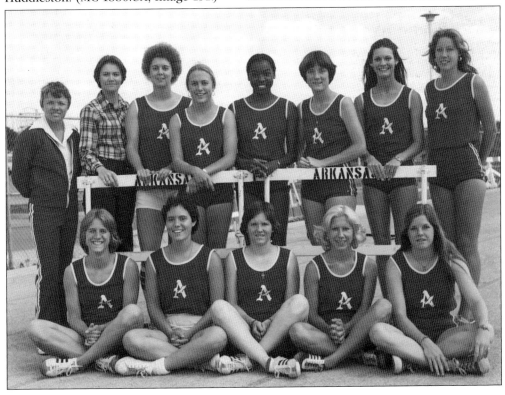

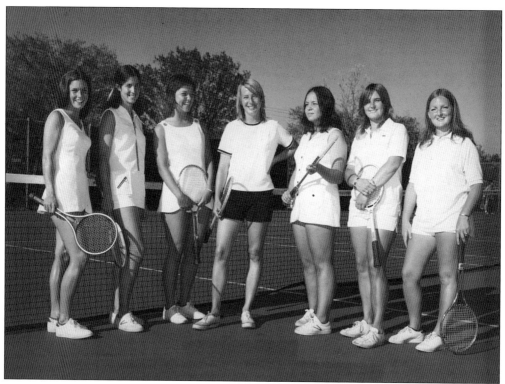

The 1973 women's tennis team placed first in the Arkansas Women's Extramural Sports Association (AWESA), which was established in the 1965–1966 academic year by women physical educators. The association changed the name to Arkansas Women's Intercollegiate Sports Association (AWISA) in 1973. From left to right are Mary Knowles, Jennie Seals, Mary Liberto, coach Deb Thompson, Lisa Hammersley, Elise Doherty, and Paula Babb. (MC 1880. UA, Image 132.)

Members of 1976–1977 Razorback gymnastics team pause from their training for a photograph. Pictured are, from left to right, (first row) Vicki Tyson and Nanette Gosnell; (second row) coach Nancy Lowe, Jody Tyson, Kenda Zwayer, Melanie Jones, Annette Ivey, and Donna Williams. With the growth of the women's athletic program, the first female athletic scholarships were awarded in 1976–1977. There were 10 women of various sports that received awards that year. (MC 1880.UA, Image 66.)

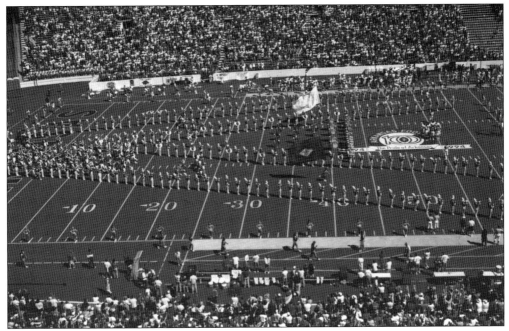

During the 1970s, band director Eldon Janzen started the big "A formation," which is still a staple before every football game. The *A* forms the path for the football team, cheerleaders, and mascot to run onto the field. The *A* became larger and more sophisticated over the years and is pictured here at a football game in the 1990s. (MC 2002.UA.)

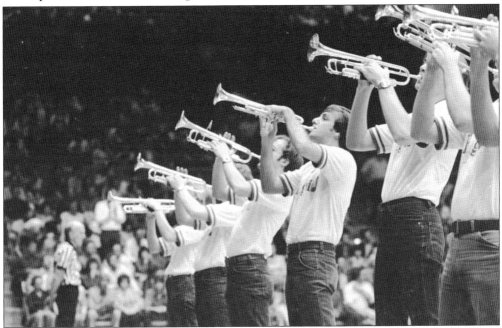

The Hogwild Band, named around 1980, does its part to cheer on the Razorbacks and keep the crowd energized during basketball games. Pictured here is the trumpet section entertaining the crowd during a 1981 game. It was during this time period that the band started playing a Razorback version of the Mac Davis hit "It's Hard to be Humble." (MC 1302, 1981-15.)

From left to right, assistant basketball coaches Mike Anderson and Scott Edgar, head coach Nolan Richardson, and players Ron Huery and Shawn Davis sit on the bench as Arkansas plays Texas Tech on January 4, 1989. Richardson was known for his coaching style of fast-paced games with high-pressure defense, which he termed "40 minutes of Hell." He took teams to the Final Four of the NCAA Tournament three times, and the team won the only national championship in Arkansas basketball in 1994. Oliver Miller, seen at left, scored 18 points during this same Texas Tech game, his personal best during that season. The Razorbacks won the game 69-62. (Above, MC 1302, 1989-73; at left, MC 1302, 1989-73.)

SOURCES

Photographs were taken from Special Collections, University of Arkansas Libraries using the following collections.

MC 589: University of Arkansas Athletic Photographs

MC 623: Edgar A. Albin Papers

MC 779: Lighton Family Papers

MC 896: Mary Celestia Parler Photographs

MC 905: Glaphyra Wilkerson Stafford Scrapbook

MC 1116: David W. Mullins Papers

MC 1157: University of Arkansas Campus Photographs, 1907–1911

MC 1302: University of Arkansas, University Relations Photographs

MC 1356: Harlan Hobbs Papers

MC 1463: Geleve Grice Photograph Collection

MC 1632: Diane D. Blair Papers

MC 1674: Herb Fowler Papers

MC 1860: Marvin Demuth Photograph Collection

MC 1880.UA: University of Arkansas Athletic Department, Women's Athletic Director Records

MC 2002.UA: University of Arkansas Bands Records

MC 2016: John K. Woodruff Papers

MC 2052.UA: Andrew Lucas Materials

MS R33: John Hugh Reynolds Photographs

Special Collections Picture Collection

DISCOVER THOUSANDS OF LOCAL HISTORY BOOKS FEATURING MILLIONS OF VINTAGE IMAGES

Arcadia Publishing, the leading local history publisher in the United States, is committed to making history accessible and meaningful through publishing books that celebrate and preserve the heritage of America's people and places.

Find more books like this at
www.arcadiapublishing.com

Search for your hometown history, your old stomping grounds, and even your favorite sports team.